1/10

"Time is an invention or it's nothing at all."
–Henri Bergson

Musée du Louvre

Henri Loyrette
President and Director

Didier Delles
General Administrator

Aline Sylla-Walbaum
Assistant General Administrator, Director of Cultural Development

Violaine Bouvet-Lanselle
Head of the Publishing Service, Office of Cultural Development

Publishing

Series Editor: Fabrice Douar
Publishing Service, Office of Cultural Development, Musée du Louvre

Acknowledgements at the Musée du Louvre
Henri Loyrette, Didier Selles, Aline Sylla, Vincent Pomarède, Christophe Monin, Violaine Bouvet-Lanselle, Catherine Dupont, Moïna Lisowski, Fanny Meurisse, Isabelle Calvi, Philippe Poncet, Nelly Girault, Chrystel Martin, Angèle Dequier, Nathalie Brac de la Perrière, Daniel Soulié, Sabine de La Rochefoucauld, Emmanuelle Peret, Zahia Chettab, Marie-Cécile Bardoz, Agnès Marconnet, Brigitte Loit, Didier Belliot, Olivier Boissard, Captain François Cesari, First Class Frédéric Denert, Head Corporal Jean-Claude Pivron, Soraya Karkache, Sixtine de Saint-Léger, Michel Antonpietri, François Vaysse, Laurence Irollo, Ludovic Rozak, Manon Potvin, Éléonore Valais, Constance Lombard;

Thanks to Yves and Catherine Thomine-Desmazures, Carole de Vellou, Laurence de Vellou, Michel Douar, Hervé Viallet, Thierry Masbou, Patrice Régnier, Cécile Bergon, Nathalie Trafford, Denis Curty, Christophe Duteil, Mathilde Chevrel, Béatrice Hedde, Anne Grandadam, Gilles et Gaëlle Marzin, Armande Bourgault, Pascal Becquet, Sophie Gormezano, Virginie d'Allens and Ariane Michaloux for their support.

ISBN 10: 1-56163-514-6
ISBN 13: 987-1-56163-514-6

MARC-ANTOINE MATHIEU

THE MUSEUM VAULTS

Excerpts from the Journal of an Expert

MUSÉE DU LOUVRE ÉDITIONS

Comicslit is an imprint
and trademark of

NANTIER · BEALL · MINOUSTCHINE
Publishing inc.
new york

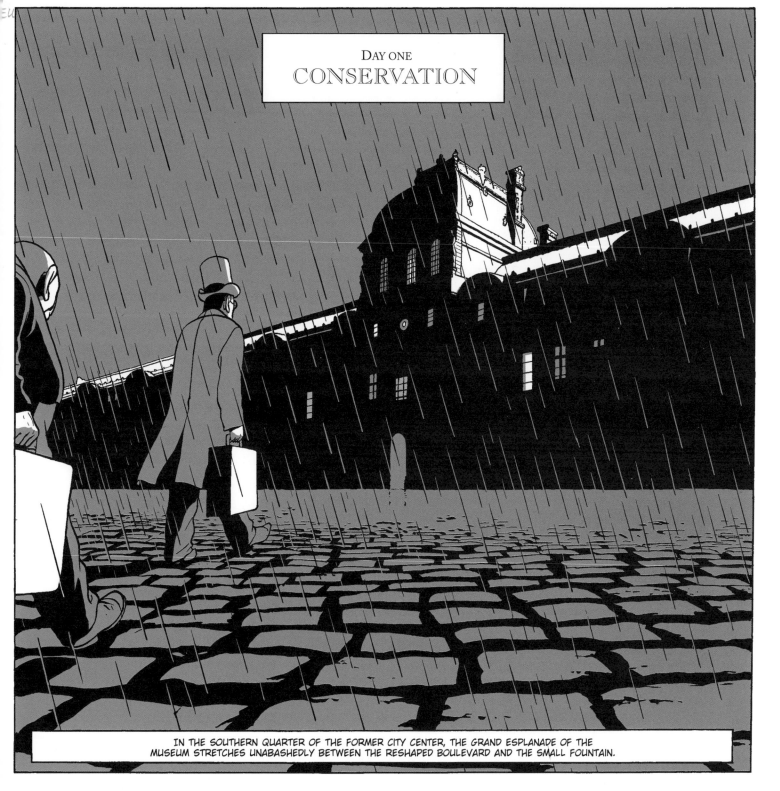

DAY ONE
CONSERVATION

IN THE SOUTHERN QUARTER OF THE FORMER CITY CENTER, THE GRAND ESPLANADE OF THE
MUSEUM STRETCHES UNABASHEDLY BETWEEN THE RESHAPED BOULEVARD AND THE SMALL FOUNTAIN.

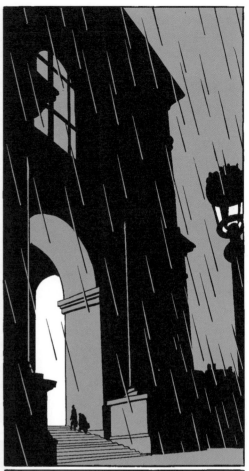

THE MUSEE DU REVOLU, THAT'S WHAT IT'S CALLED NOWADAYS.

BUT OTHERS CALL IT "LI RUDE LOVE MUSE," OTHERS THE "OEUVRE DUE SLUM," OR ALSO THE "LOUD MUSE REVUE."

THEY SAY THAT ALL THESE NAMES ARE NOTHING BUT ANAGRAMS OF THE MUSEUM'S REAL NAME, WHICH HAS BEEN FORGOTTEN.

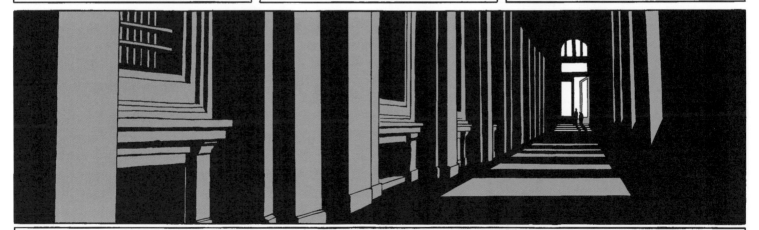

FOR MY PART, I'D SAY THAT ITS NAME HASN'T YET BEEN FOUND, FOR IF IT'S TRUE THAT ONE ONLY DEFINITIVELY NAMES THINGS THAT ONE CAN GRASP, THEN THE MUSEUM MUST BE MOST DIFFICULT TO DEFINE.

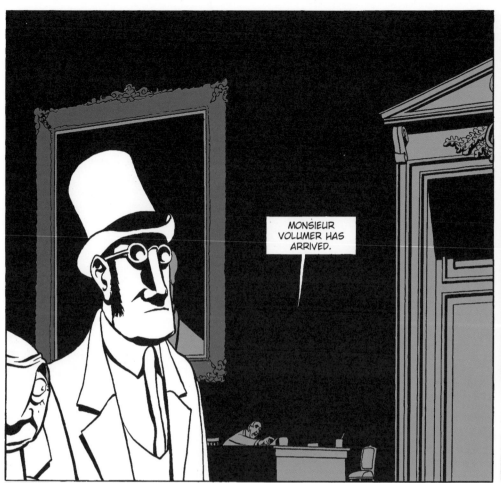

MONSIEUR VOLUMER HAS ARRIVED.

THIS SORT OF OBSERVATION TENDS TO FAVOR THE THESIS ACCORDING TO WHICH THE MUSEUM REMAINS UNNAMEABLE, I DO REALIZE...

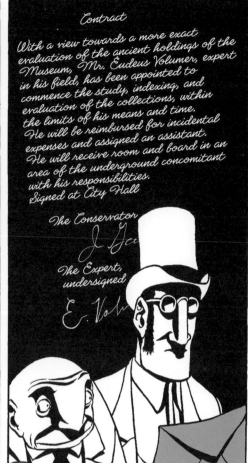

Contract

With a view towards a more exact evaluation of the ancient holdings of the Museum, Mr. Eudeus Volumer, expert in his field, has been appointed to commence the study, indexing, and evaluation of the collections, within the limits of his means and time.
He will be reimbursed for incidental expenses and assigned an assistant.
He will receive room and board in an area of the underground concomitant with his responsibilities.
Signed at City Hall

The Conservator

The Expert, undersigned

...BUT, HEY, THEY DIDN'T HIRE ME TO BE FEEDING INTO THE REVOLU'S HERMENEUTICS.

PSSST!

THIS WAY, GENTLEMEN

MONSIEUR VOLUMER?

IT'S LIKE A NAME OF PREDESTINATION.

YES, IT'S TRUE THAT THE ESSENCE OF MY MISSION CONSISTS IN QUANTIFYING.

AHH, THE STAIRWELLS, THE HALLWAYS, THE CORRIDORS, THE HALF-LEVELS YOU'LL SEE. YOU'LL END UP GETTING USED TO IT ALL.

AT FIRST, YOU LOOK FOR REFERENCE POINTS... YOU GET LOST.

EXCUSE ME, IS CONSERVATION XXII DOWN THIS WAY?

UH, NOPE. THAT WAY.

BUT OVER TIME, YOU DEVELOP AN INSTINCT OF SORTS, LIKE AN INFALLIBLE SENSE OF ORIENTATION.

ONE DAY, YOU TOO, WILL DEVELOP THAT GYROSCOPIC ORGAN.

LIKE THAT OF BIRDS'.

WHERE WILL YOU BE STARTING?

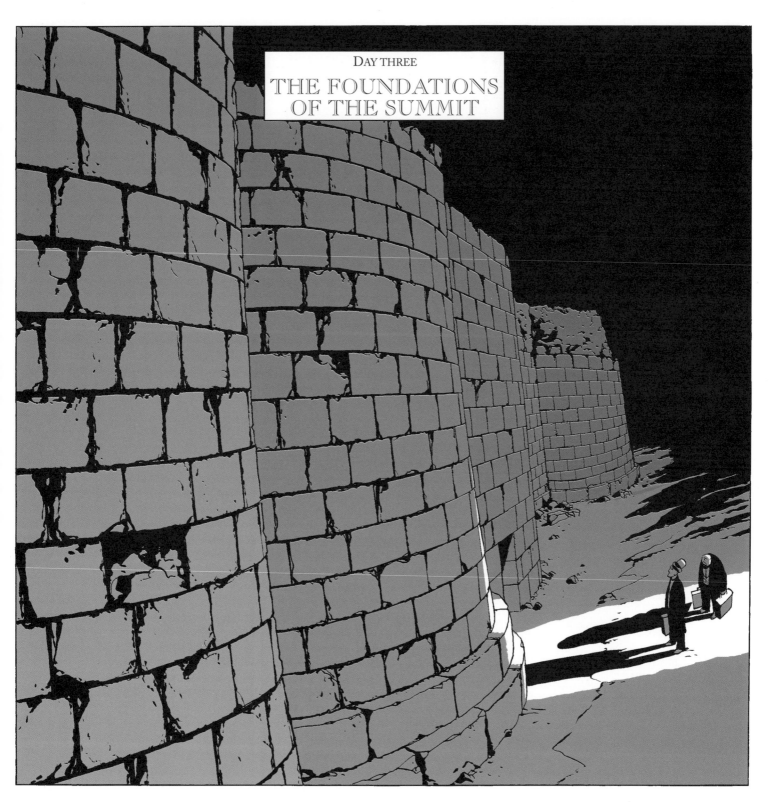

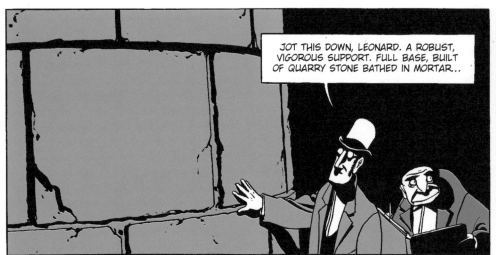

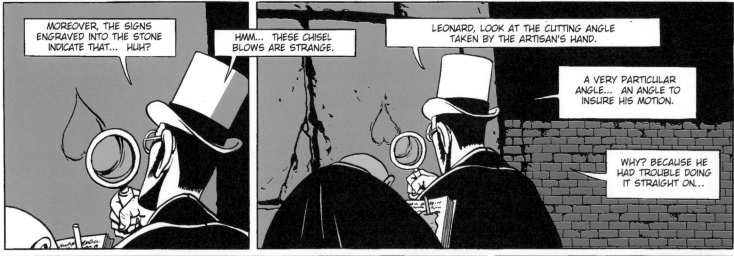

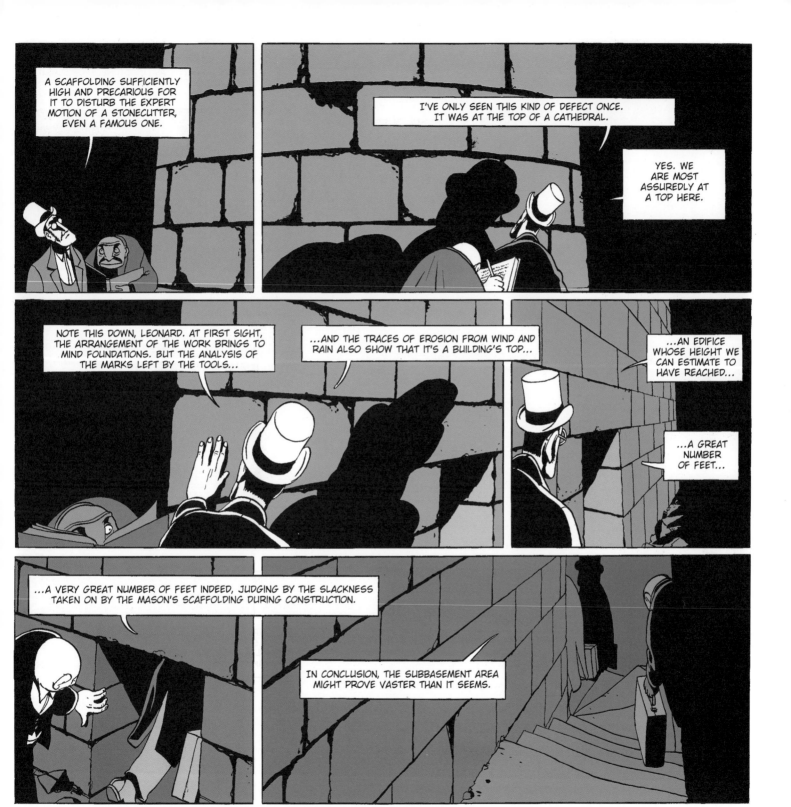

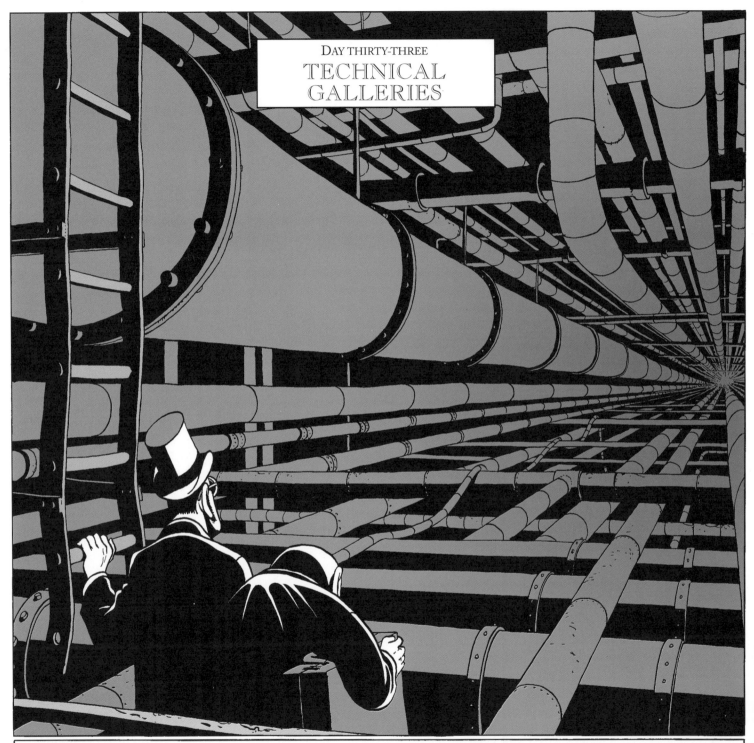

THE INSPECTION THESE LATTER MONTHS OF THE TECHNICAL SECTIONS HAS CONFIRMED MY FIRST IMPRESSION AND IS MAKING ME RECONSIDER THE EXTENT OF THE SUBBASEMENT AREA. I KNEW THE MUSEUM WAS REMARKABLE WITH RESPECT TO ITS SPIRIT, BUT I WAS UNAWARE THAT IT WAS IN SIZE, ALSO.

THE TAPESTRY WORKSHOPS ARE SO LARGE THAT I HAD TO RESTRICT MY INVESTIGATION TO THE ESSENTIALS OF THE FURNISHINGS OF VALUE.

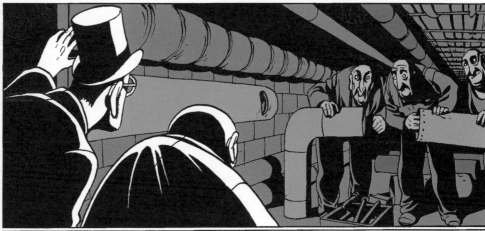

ALL BY ITSELF, THE "LITTLE" RESERVED AREA FOR PICTURE RAIL MOLDING OCCUPIES AN ENTIRE LEVEL.

THE EXIT? FOLLOW THE PATH OF THE CABLE!

THE FORTUITOUS VISIT THESE LAST DAYS OF THE INTERMINABLE TECHNICAL PASSAGEWAYS COMFORTS ME IN MY CONCLUSION:

THIS MISSION WILL TAKE ME MUCH LONGER THAN PLANNED.

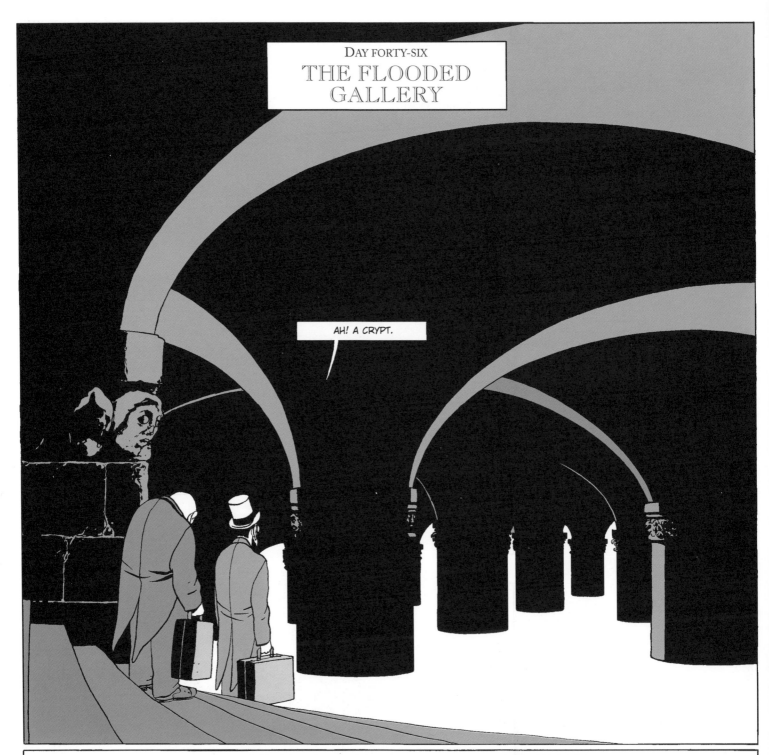

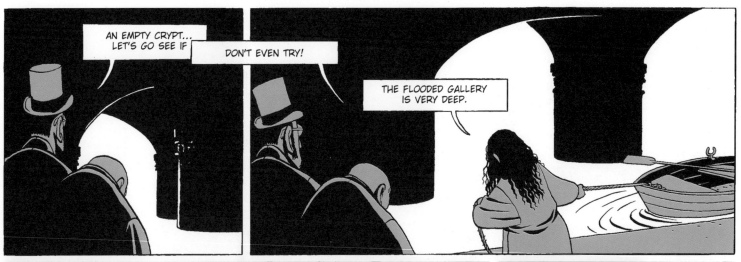

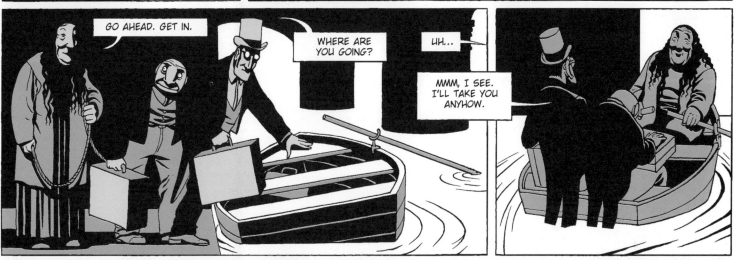

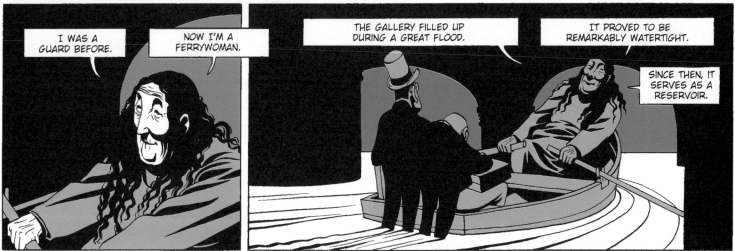

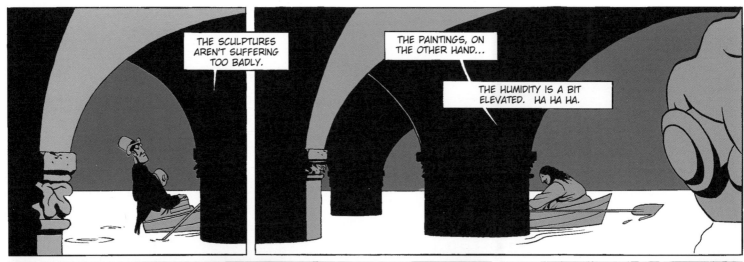

THE SCULPTURES AREN'T SUFFERING TOO BADLY.

THE PAINTINGS, ON THE OTHER HAND...

THE HUMIDITY IS A BIT ELEVATED. HA HA HA.

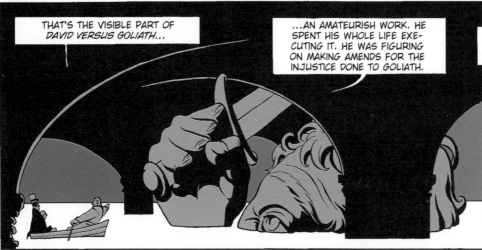

THAT'S THE VISIBLE PART OF *DAVID VERSUS GOLIATH*...

...AN AMATEURISH WORK. HE SPENT HIS WHOLE LIFE EXECUTING IT. HE WAS FIGURING ON MAKING AMENDS FOR THE INJUSTICE DONE TO GOLIATH.

WHAT TOUCHING NAIVETE.

YES! ONE COULDN'T CREATE ANY MORE POMPOUS WORK.

FOR HERE WE'RE IN THE GALLERY OF THE 'ARTS POMPIERS', POMPOUS ARTWORK.

NOTE THE IRONY. POMP SUBMERGED. THE POMP NEEDS PUMPING. HA HA HA!

ACCORDING TO THE FERRYWOMAN, THERE ARE 400 PAINTINGS AND 150 SCULPTURES UNDER WATER HERE AN ESTIMATE TO BE MADE MORE PRECISE BY SEARCHING THROUGH THE GENERAL INVENTORY.

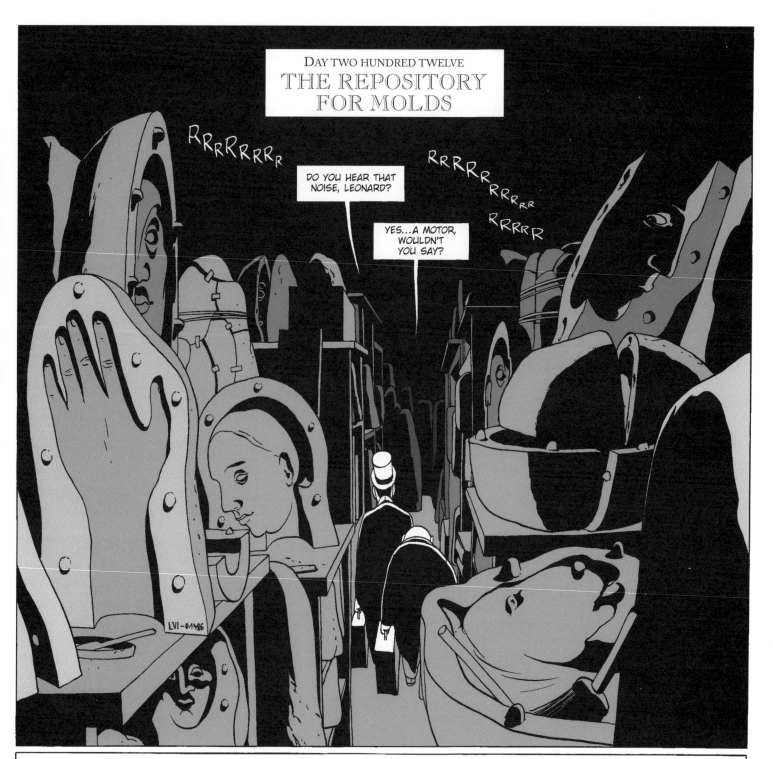

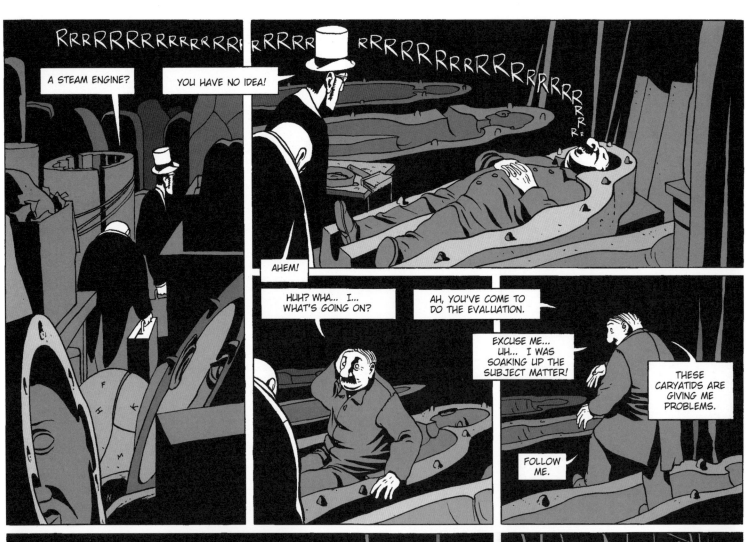

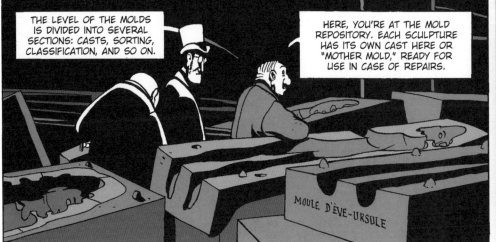

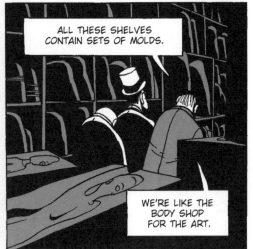

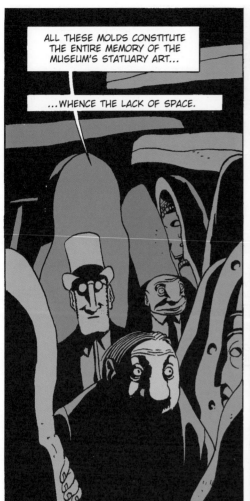

ALL THESE MOLDS CONSTITUTE THE ENTIRE MEMORY OF THE MUSEUM'S STATUARY ART...

...WHENCE THE LACK OF SPACE.

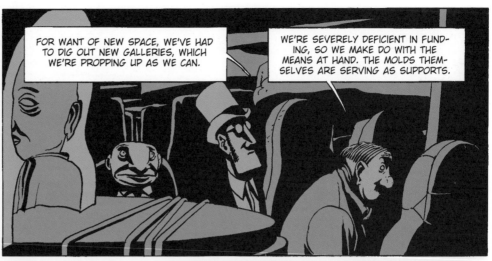

FOR WANT OF NEW SPACE, WE'VE HAD TO DIG OUT NEW GALLERIES, WHICH WE'RE PROPPING UP AS WE CAN.

WE'RE SEVERELY DEFICIENT IN FUNDING, SO WE MAKE DO WITH THE MEANS AT HAND. THE MOLDS THEMSELVES ARE SERVING AS SUPPORTS.

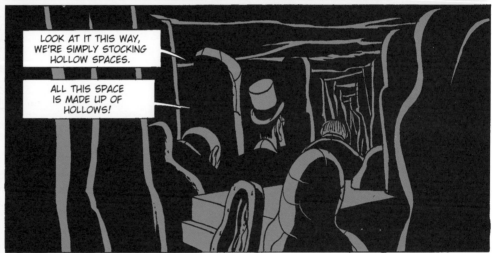

LOOK AT IT THIS WAY, WE'RE SIMPLY STOCKING HOLLOW SPACES.

ALL THIS SPACE IS MADE UP OF HOLLOWS!

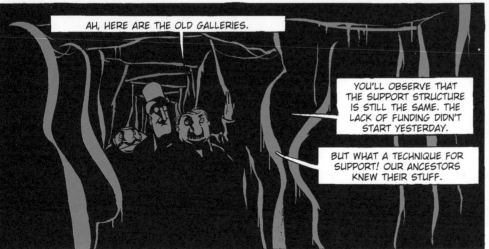

AH, HERE ARE THE OLD GALLERIES.

YOU'LL OBSERVE THAT THE SUPPORT STRUCTURE IS STILL THE SAME. THE LACK OF FUNDING DIDN'T START YESTERDAY.

BUT WHAT A TECHNIQUE FOR SUPPORT! OUR ANCESTORS KNEW THEIR STUFF.

OUR ANCESTORS?

YES, THE DEEPER YOU GO IN THE GALLERIES, THE FARTHER YOU'RE GOING BACK IN TIME.

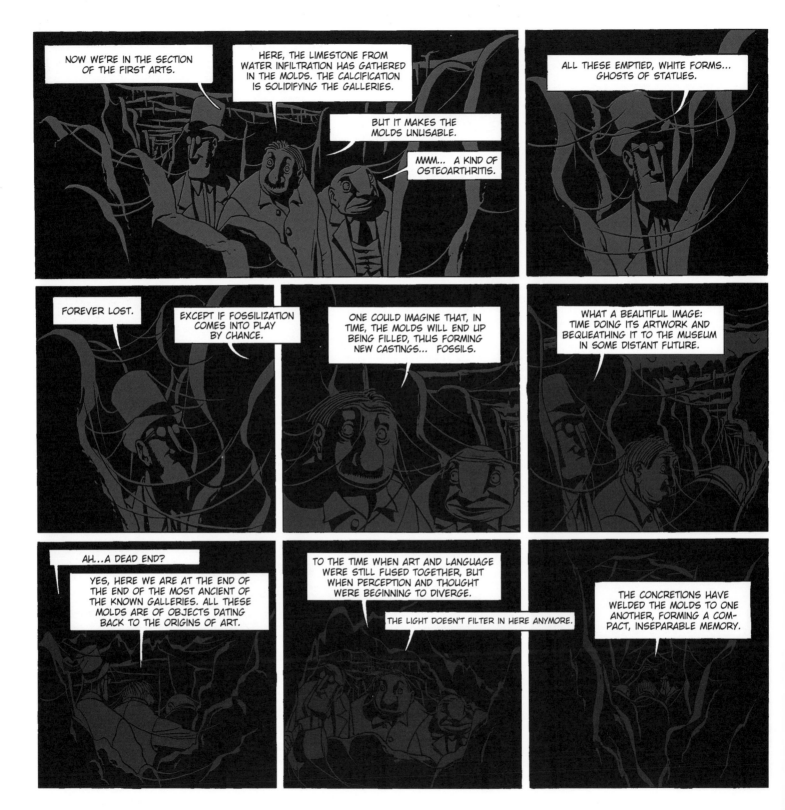

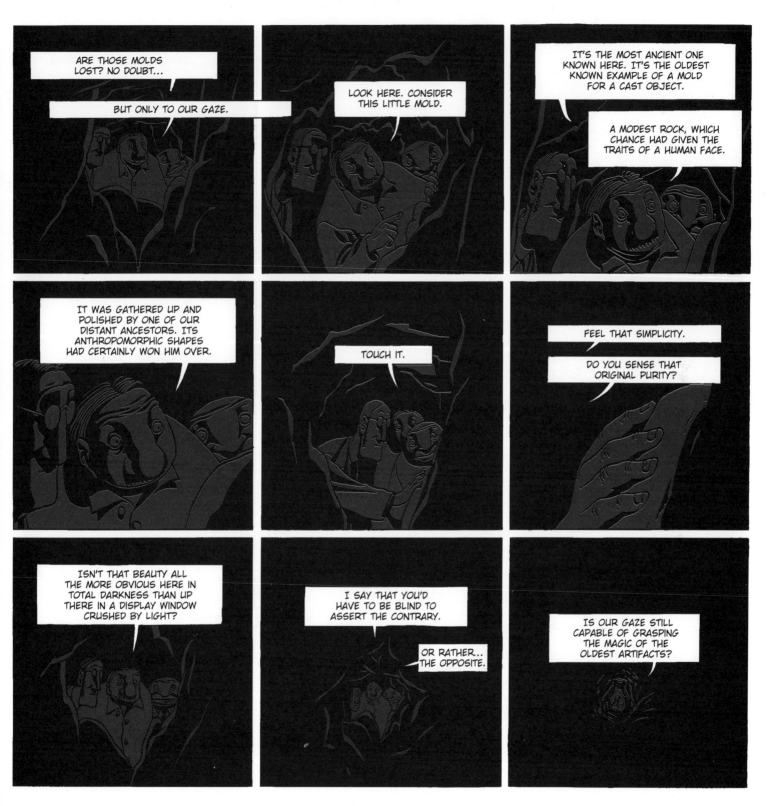

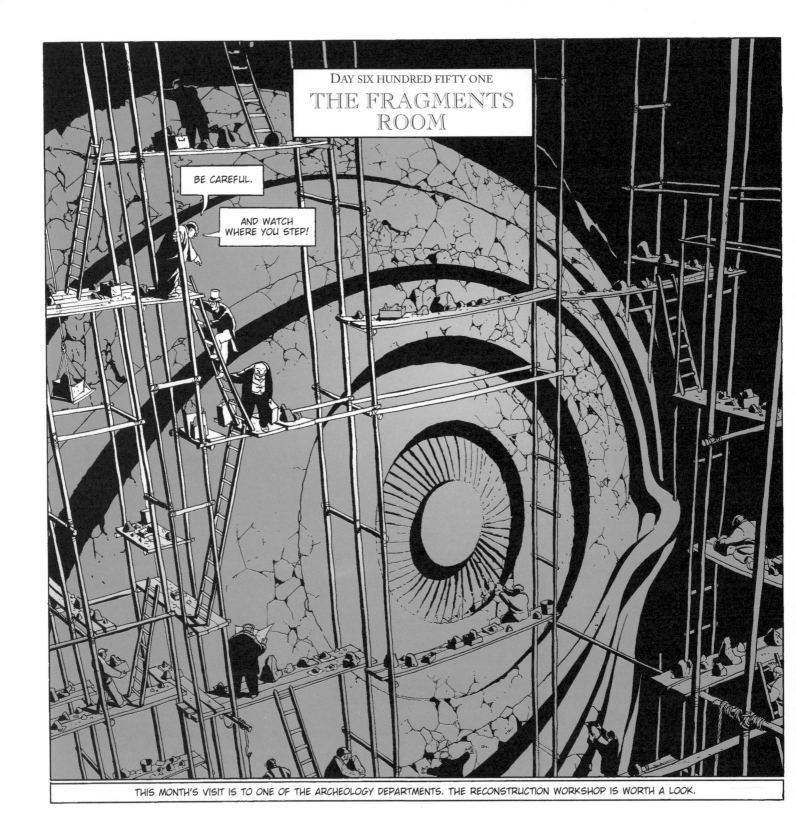

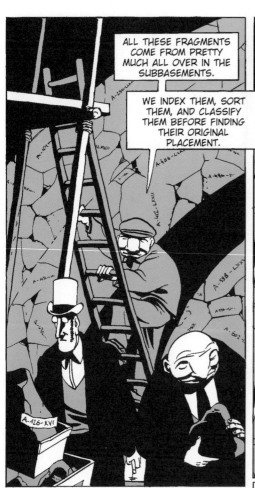

ALL THESE FRAGMENTS COME FROM PRETTY MUCH ALL OVER IN THE SUBBASEMENTS.

WE INDEX THEM, SORT THEM, AND CLASSIFY THEM BEFORE FINDING THEIR ORIGINAL PLACEMENT.

ALL THESE FRAGMENTS ORIGINALLY WERE PART OF THE SAME BLOCK OF STONE.

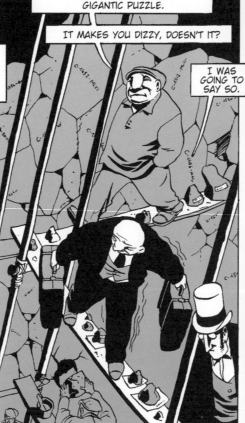

YES, IT'S A PUZZLE. ONE GIGANTIC PUZZLE.

IT MAKES YOU DIZZY, DOESN'T IT?

I WAS GOING TO SAY SO.

CONSIDERING THE SIZE OF THE VESTIGE RESTORED HERE, WE CAN DEDUCE A SCULPTURE OF GREAT PROPORTIONS...

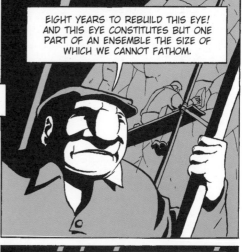

EIGHT YEARS TO REBUILD THIS EYE! AND THIS EYE CONSTITUTES BUT ONE PART OF AN ENSEMBLE THE SIZE OF WHICH WE CANNOT FATHOM.

THE FRAGMENTS STORED IN THE STORAGE AREAS 11 AND 12 CORRESPOND TO A HAND. STORAGE 9 CONTAINS FRAGMENTS OF A SHOULDER, AND SO ON.

...OF AN EVEN MONUMENTAL SIZE.

CURIOUSLY, UP TILL NOW, WE'VE ONLY FOUND A SINGLE EYE, WHICH MAKES CERTAIN PEOPLE SAY THAT THE STATUE AS A WHOLE MIGHT FORM A CYCLOPS.

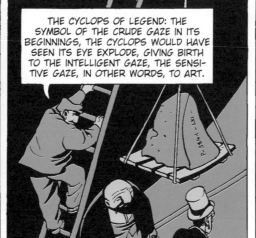

THE CYCLOPS OF LEGEND: THE SYMBOL OF THE CRUDE GAZE IN ITS BEGINNINGS, THE CYCLOPS WOULD HAVE SEEN ITS EYE EXPLODE, GIVING BIRTH TO THE INTELLIGENT GAZE, THE SENSITIVE GAZE, IN OTHER WORDS, TO ART.

AND THE MUSEUM WOULD TAKE ROOT IN THE GIGANTIC CRATER RESULTING FROM THE EXPLOSION.

IT'S BUT ONE OF THE NUMEROUS LEGENDS CIRCULATING IN THE SUBBASEMENTS.

EVOKES A SHE-WOLF.

YET ANOTHER SPEAKS OF A MUSE.

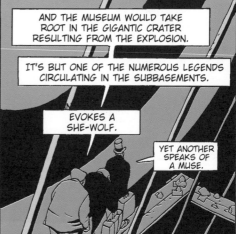

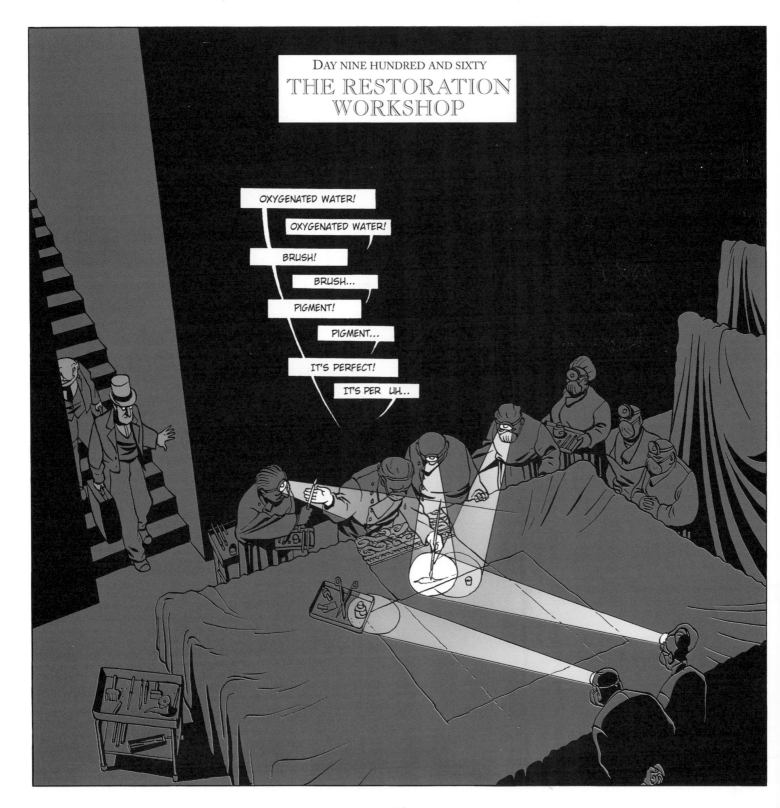

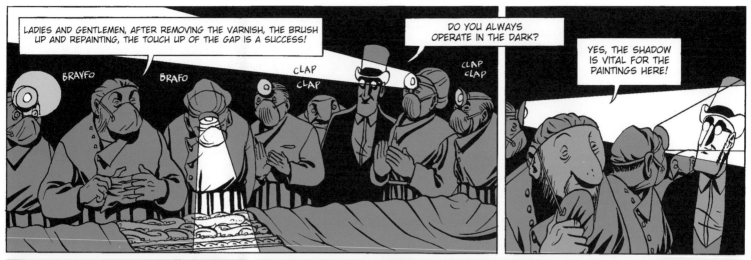

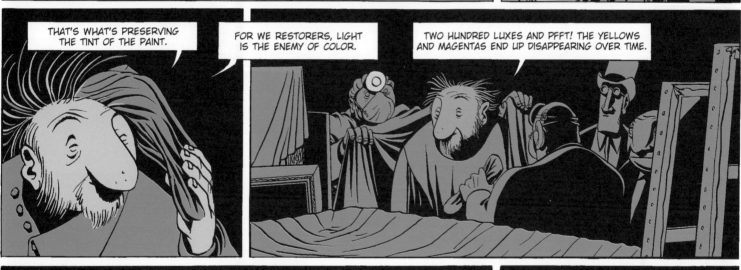

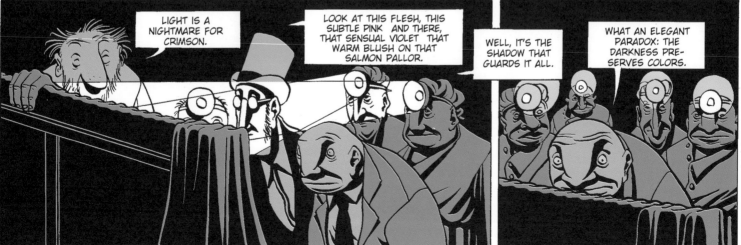

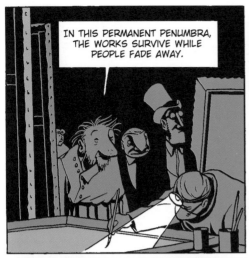

IN THIS PERMANENT PENUMBRA, THE WORKS SURVIVE WHILE PEOPLE FADE AWAY.

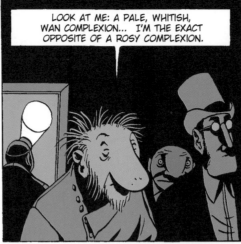

LOOK AT ME: A PALE, WHITISH, WAN COMPLEXION... I'M THE EXACT OPPOSITE OF A ROSY COMPLEXION.

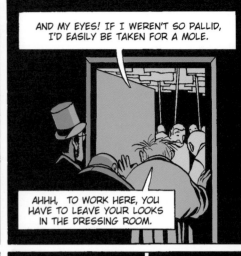

AND MY EYES! IF I WEREN'T SO PALLID, I'D EASILY BE TAKEN FOR A MOLE.

AHHH, TO WORK HERE, YOU HAVE TO LEAVE YOUR LOOKS IN THE DRESSING ROOM.

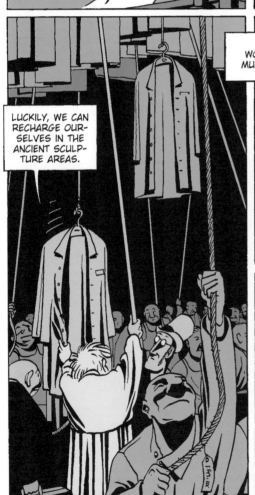

LUCKILY, WE CAN RECHARGE OUR-SELVES IN THE ANCIENT SCULP-TURE AREAS.

THEIR WORKSHOPS ARE MUCH BETTER LIT.

IT'S THIS WAY.

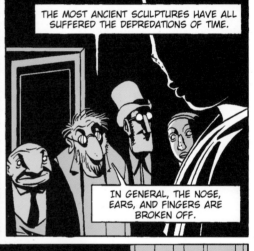

THE MOST ANCIENT SCULPTURES HAVE ALL SUFFERED THE DEPREDATIONS OF TIME.

IN GENERAL, THE NOSE, EARS, AND FINGERS ARE BROKEN OFF.

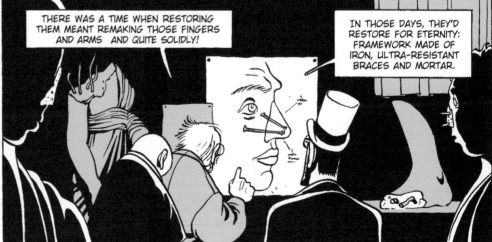

THERE WAS A TIME WHEN RESTORING THEM MEANT REMAKING THOSE FINGERS AND ARMS AND QUITE SOLIDLY!

IN THOSE DAYS, THEY'D RESTORE FOR ETERNITY: FRAMEWORK MADE OF IRON, ULTRA-RESISTANT BRACES AND MORTAR.

AND THEN THAT ERA OF RESTORATION FELL OUT OF FASHION. IT WAS NECESSARY TO GET BACK TO THE "ORIGINAL" WORKS, WITH THEIR ORIGINAL AMPUTATIONS. IT WAS NECESSARY THENCEFORTH TO LEAVE THE TRACES OF DETERIORATION CAUSED BY TIME.

SO EVERYTHING HAD TO BE RE-BROKEN.

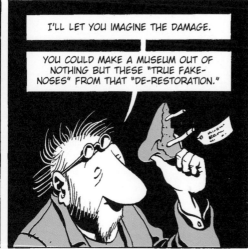

I'LL LET YOU IMAGINE THE DAMAGE.

YOU COULD MAKE A MUSEUM OUT OF NOTHING BUT THESE "TRUE FAKE-NOSES" FROM THAT "DE-RESTORATION."

SO THE ORIGINAL BREAKS HAD TO BE REBUILT. THIS RESTORATION OF THE ORIGINAL BREAKS REQUIRES VERY PERILOUS AESTHETIC GYMNASTICS.

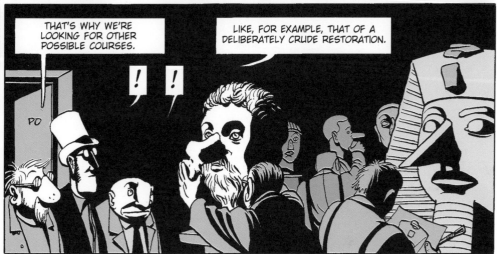

THAT'S WHY WE'RE LOOKING FOR OTHER POSSIBLE COURSES.

LIKE, FOR EXAMPLE, THAT OF A DELIBERATELY CRUDE RESTORATION.

THIS CONCEPT OF A RESOLUTELY INTER-VENTIONIST RESTORATION DEFENDS THE PRINCIPLE OF AN "OPEN-EYED" REPAIR.

IT SIMULTANEOUSLY ALLOWS FOR NOT DECEIVING THE VIEWER (WHO INSTANTLY SEES THAT THE WORK WAS DAMAGED, SINCE IT'S OBVIOUSLY BEEN REPAIRED)...

...AND ALSO LETS US KNOW AT FIRST GLANCE ABOUT THE PLACE WHERE IT'LL BE NECESSARY TO BREAK IT THE NEXT TIME, WHEN THERE'S A NEW DIRECTIVE. THAT WAY WE DON'T RISK DISFIGURING THE WORKS!

IT'S A DARING IDEA, IT'S TRUE. BUT RESTORING THE PAST MUSTN'T KEEP US FROM MOVING FORWARD.

LEARNING LESSONS FROM THE PAST AND INNOVATING: THAT'S WHAT NEO-RESTORATION IS.

OHHH!?

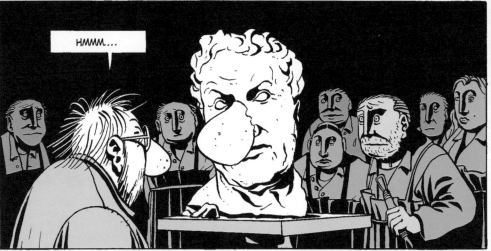

HMMM....

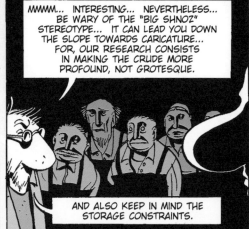

MMMM... INTERESTING... NEVERTHELESS... BE WARY OF THE "BIG SHNOZ" STEREOTYPE... IT CAN LEAD YOU DOWN THE SLOPE TOWARDS CARICATURE... FOR, OUR RESEARCH CONSISTS IN MAKING THE CRUDE MORE PROFOUND, NOT GROTESQUE.

AND ALSO KEEP IN MIND THE STORAGE CONSTRAINTS.

THEY'RE A GOOD TEAM: SERIOUS, CONSCIENTIOUS, AND ALWAYS READY TO EXPERIMENT WITH NEW TECHNIQUES.

DON'T LET TIME DO ITS WORK.

I ALWAYS SAY: RESTORATION IS ONE HECK OF A CUISINE!

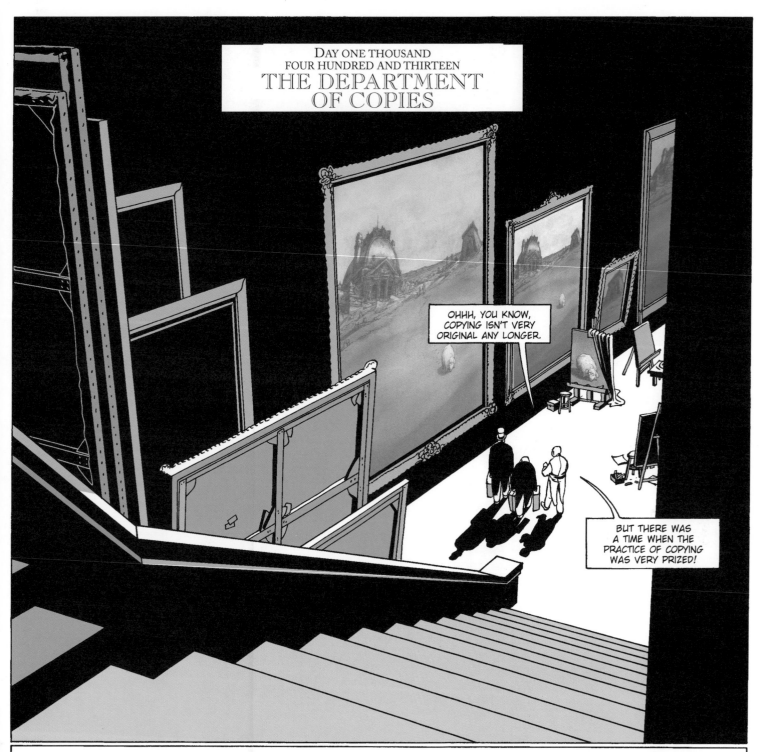

DAY ONE THOUSAND
FOUR HUNDRED AND THIRTEEN
THE DEPARTMENT OF COPIES

OHHH, YOU KNOW, COPYING ISN'T VERY ORIGINAL ANY LONGER.

BUT THERE WAS A TIME WHEN THE PRACTICE OF COPYING WAS VERY PRIZED!

FEW PEOPLE WERE AWARE OF THE EXISTENCE OF THE IMPRESSIVE QUANTITY OF PAINTING REPRODUCTIONS, AND FOR GOOD CAUSE: SINCE THE ART OF COPYING WAS NO LONGER HIGHLY REGARDED, ITS CONSERVATION WAS RELEGATED TO THE SIXTEENTH SUBBASEMENT.

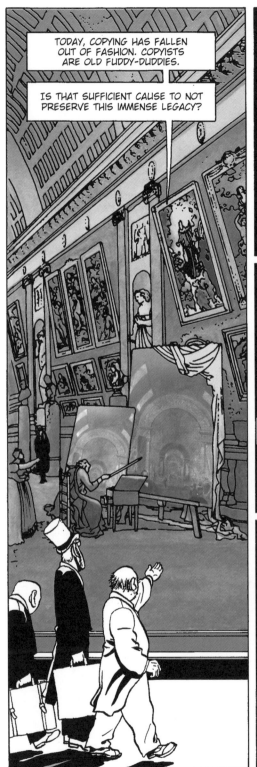

TODAY, COPYING HAS FALLEN OUT OF FASHION. COPYISTS ARE OLD FUDDY-DUDDIES.

IS THAT SUFFICIENT CAUSE TO NOT PRESERVE THIS IMMENSE LEGACY?

AAAH! COPYING ISN'T WHAT IS USED TO BE BACK THEN. IT WAS MAGNIFICENT.

AND THEN THE GENRE WAS DEBASED.

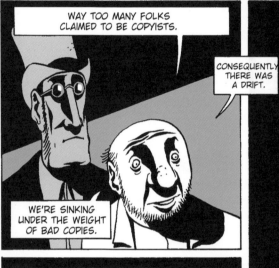

WAY TOO MANY FOLKS CLAIMED TO BE COPYISTS.

CONSEQUENTLY THERE WAS A DRIFT.

WE'RE SINKING UNDER THE WEIGHT OF BAD COPIES.

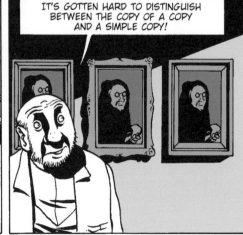

IT'S GOTTEN HARD TO DISTINGUISH BETWEEN THE COPY OF A COPY AND A SIMPLE COPY!

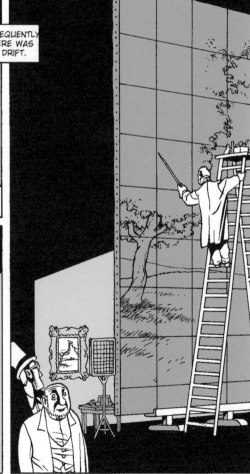

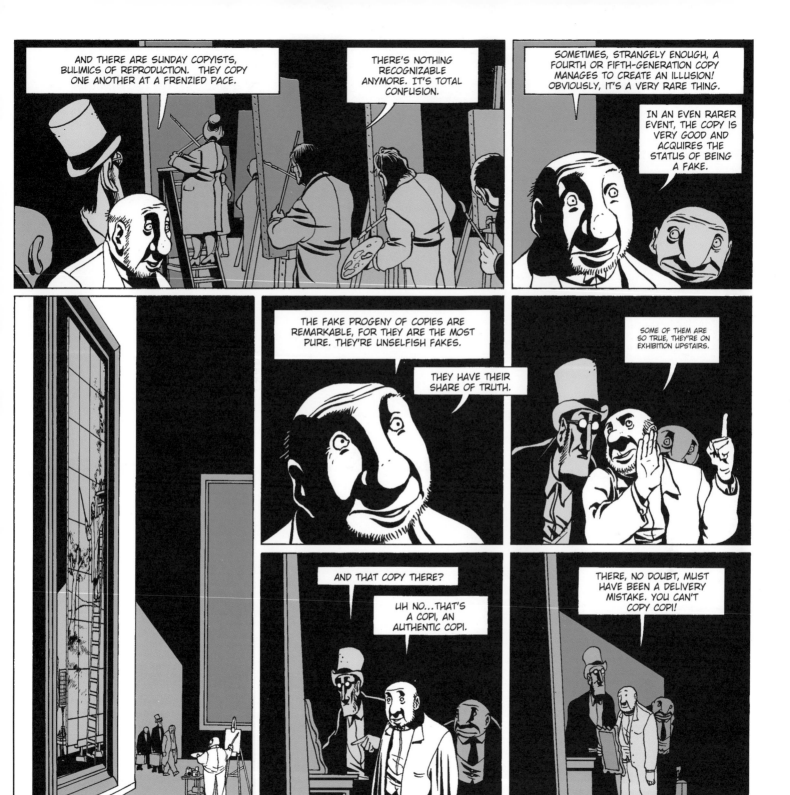

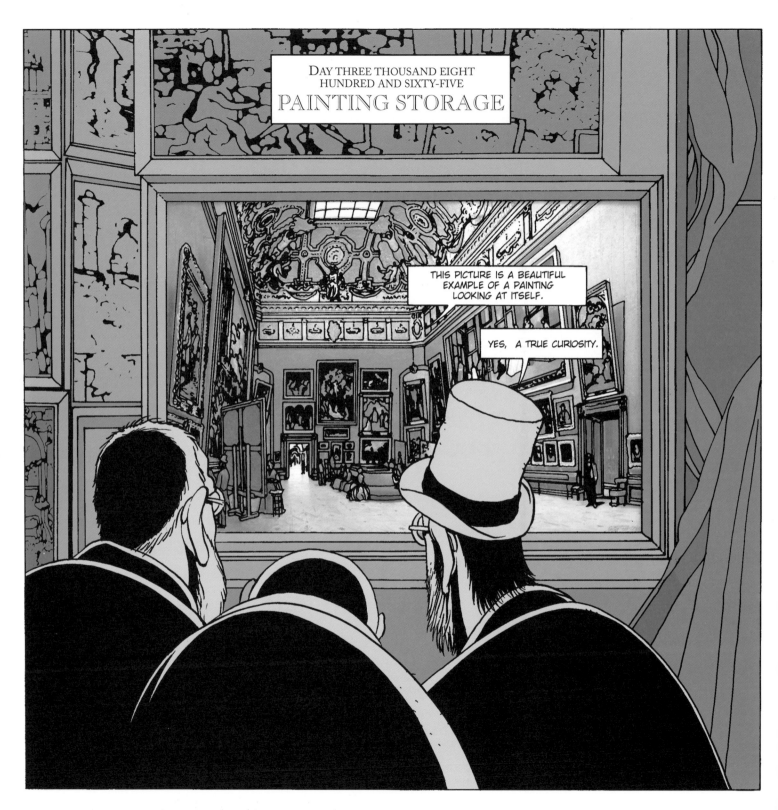

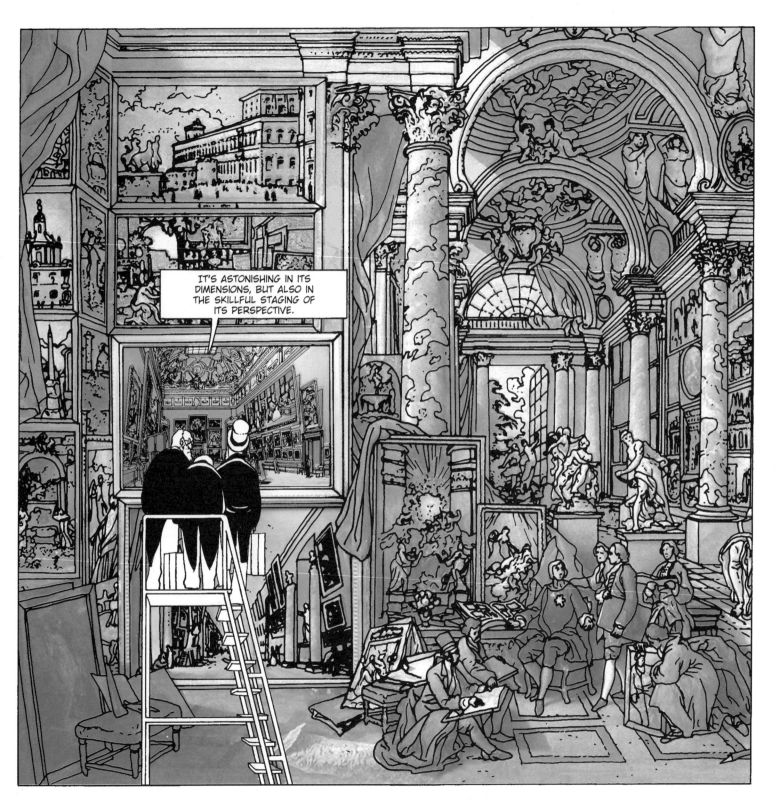

33

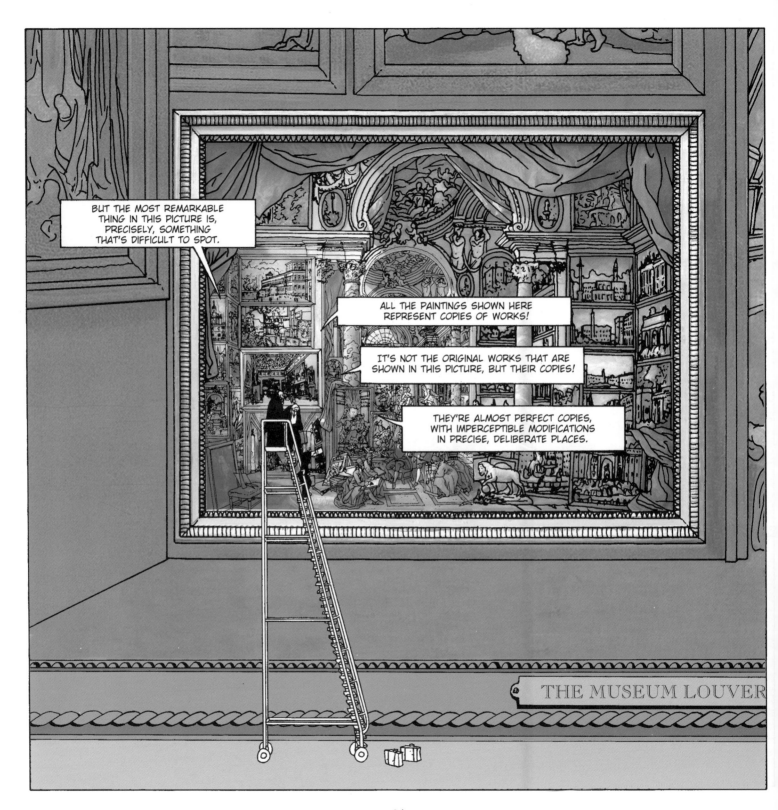

34

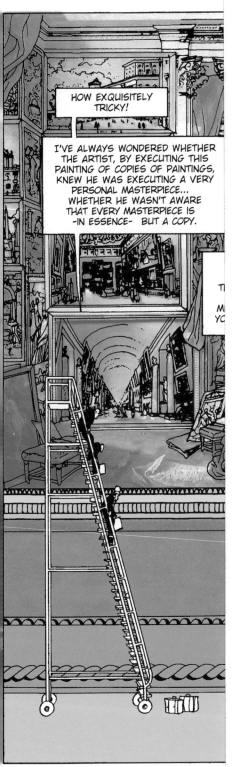

HOW EXQUISITELY TRICKY!

I'VE ALWAYS WONDERED WHETHER THE ARTIST, BY EXECUTING THIS PAINTING OF COPIES OF PAINTINGS, KNEW HE WAS EXECUTING A VERY PERSONAL MASTERPIECE... WHETHER HE WASN'T AWARE THAT EVERY MASTERPIECE IS -IN ESSENCE- BUT A COPY.

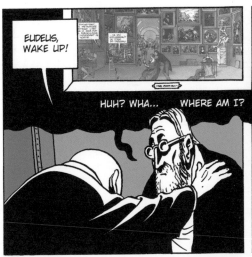

EUDELIS, WAKE UP!

HUH? WHA... WHERE AM I?

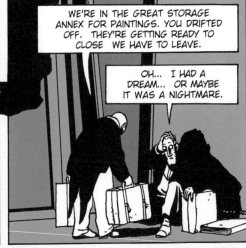

WE'RE IN THE GREAT STORAGE ANNEX FOR PAINTINGS. YOU DRIFTED OFF. THEY'RE GETTING READY TO CLOSE WE HAVE TO LEAVE.

OH... I HAD A DREAM... OR MAYBE IT WAS A NIGHTMARE.

IMAGINE AN INFINITE PAINTING... A PAINTING OF MUSEUM PAINTINGS OF... ETC... AND WE WERE PART OF THEM.

AND ALL THOSE PAINTINGS WERE NOTHING BUT COPIES!

CAN YOU GRASP IT, LEONARD? NOT ONLY WERE WE BUT REPRESENTATIONS, BUT WE WERE FAKES TO BOOT! IT'S HORRIBLE!

COME, COME ALL THESE APPRAISALS ARE WEARING YOU OUT.

YOU HAVE TO ADMIT THAT MONTHS AND MONTHS OF ALL THESE PAINTINGS ENDS UP BECOMING AN OBSESSION.

THE MUSEUM LOU-VER... THE MUSEUM OF THE LOUVER...

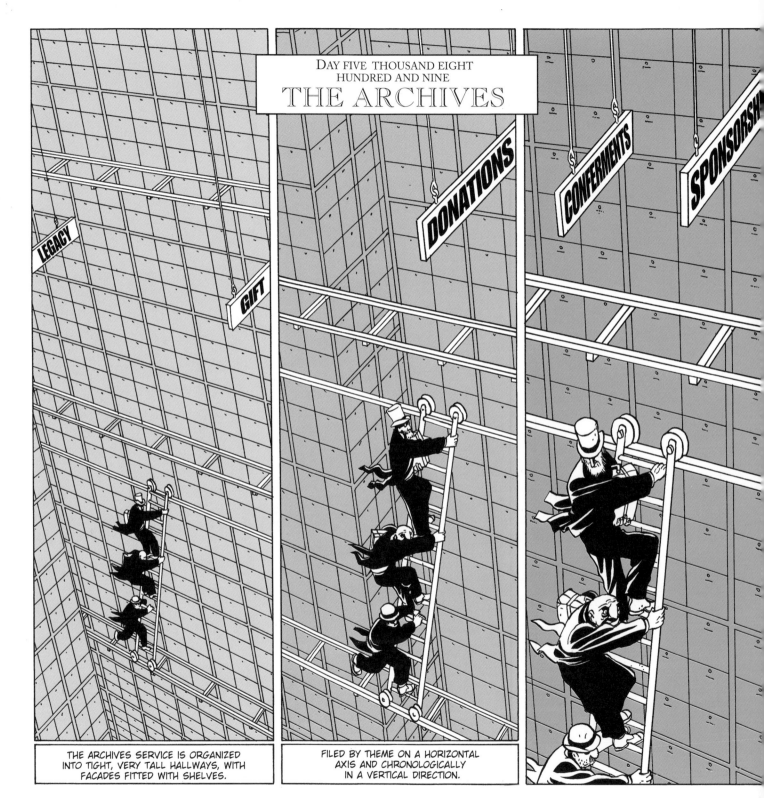

DAY FIVE THOUSAND EIGHT
HUNDRED AND NINE
THE ARCHIVES

LEGACY

GIFT

DONATIONS

CONFERMENTS

SPONSORSH

THE ARCHIVES SERVICE IS ORGANIZED
INTO TIGHT, VERY TALL HALLWAYS, WITH
FACADES FITTED WITH SHELVES.

FILED BY THEME ON A HORIZONTAL
AXIS AND CHRONOLOGICALLY
IN A VERTICAL DIRECTION.

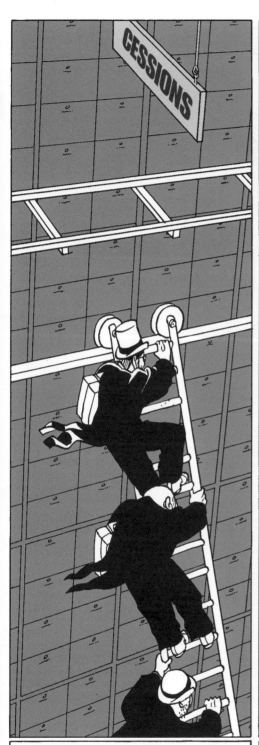

I'LL SPARE YOU A VISIT TO THE INVENTORY WINGS; IT'S EVEN MORE BORING.

WE WON'T EXPAND ANY FURTHER ON THESE ARCHIVES EVEN IF THE WHOLE SYSTEM MAY WELL DESERVE TO BE CALLED A WORK OF ART...

...INSOFAR AS ITS ARCHITECTURE MAKES IT AN OBJECT APT TO SUGGEST INFINITY. SO I WON'T INTEREST MYSELF IN THE CONTENTS...

...BUT IN THE DESCRIPTION OF ITS FORM, IN THE HOPE THAT THIS SERVICE WILL ONE DAY BE INDEXED MADE PART OF OUR NATIONAL PATRIMONY.

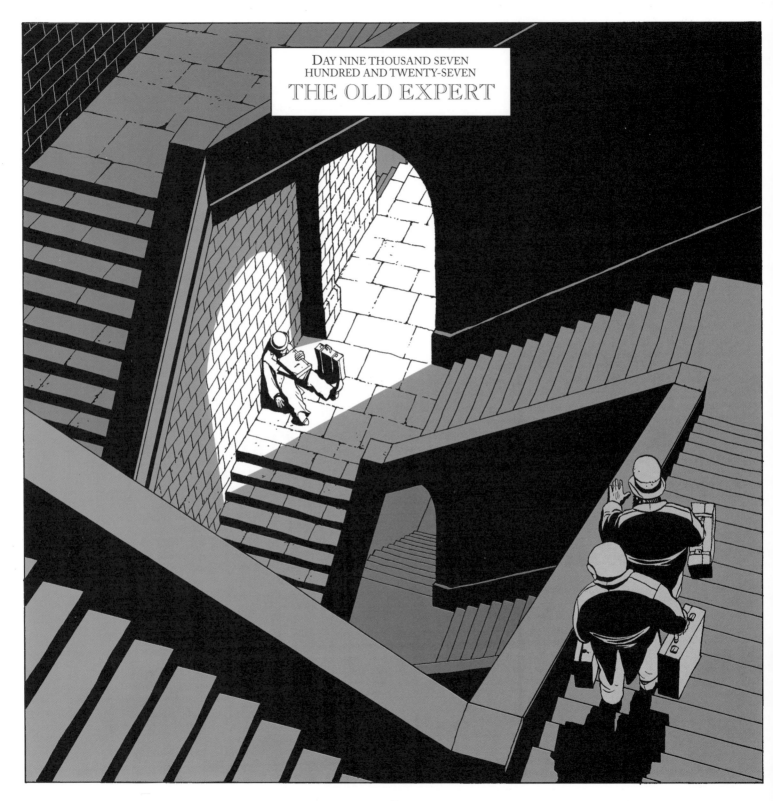

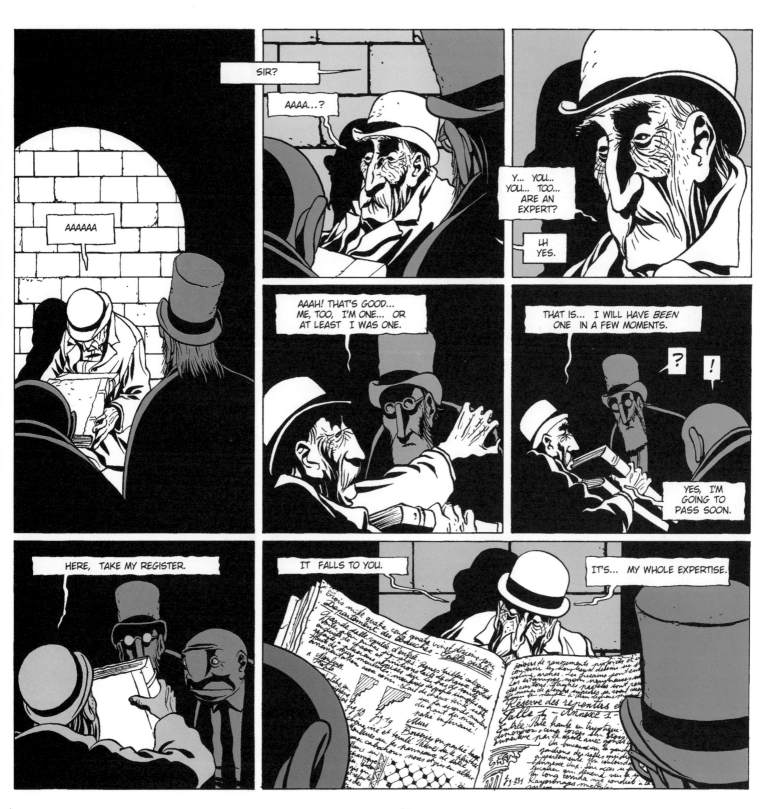

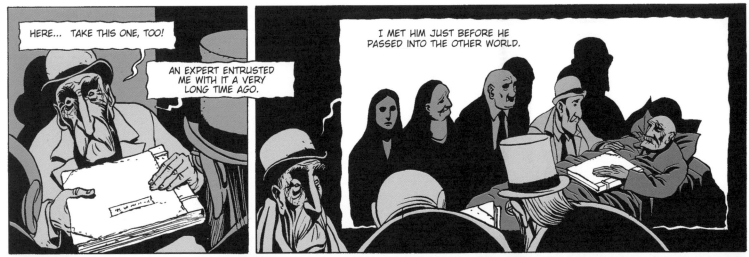

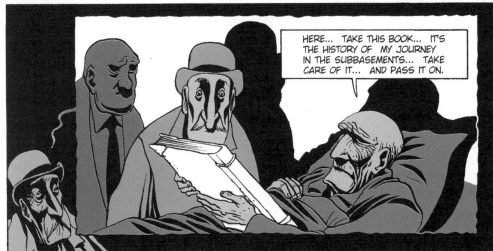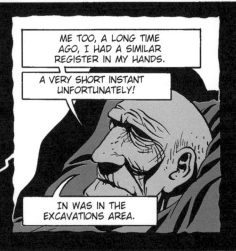

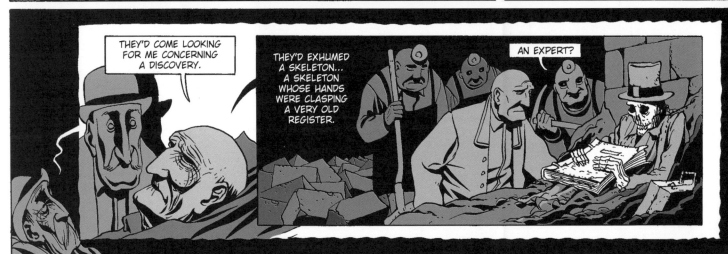

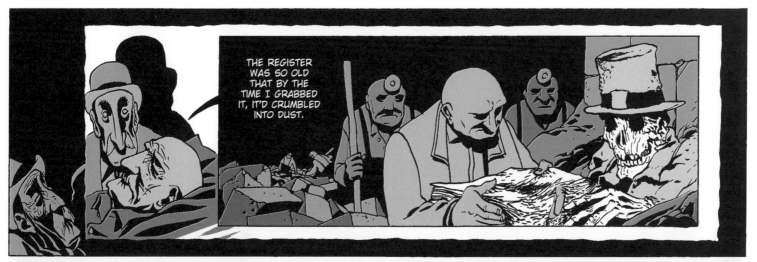

THE REGISTER WAS SO OLD THAT BY THE TIME I GRABBED IT, IT'D CRUMBLED INTO DUST.

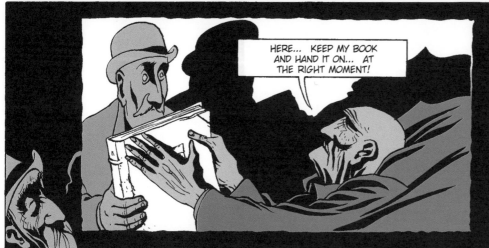

HERE... KEEP MY BOOK AND HAND IT ON... AT THE RIGHT MOMENT!

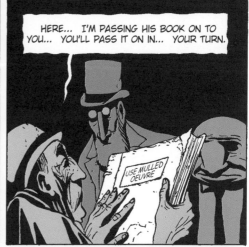

HERE... I'M PASSING HIS BOOK ON TO YOU... YOU'LL PASS IT ON IN... YOUR TURN.

USE MULLED OEUVRE

IN MEMORY OF THE DUST... YES... I'LL DO SO.

"USE MULLED OEUVRE"...

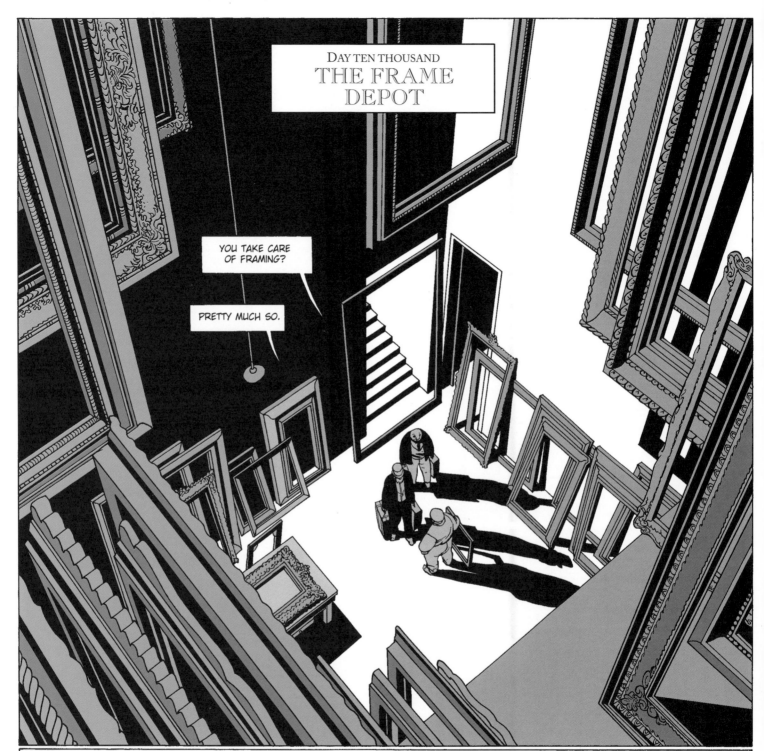

CAREFUL, THOUGH. THE FRAMING SHOP IS HIGHER UP, ON THE TWENTY-SEVENTH SUBBASEMENT.

HERE YOU'RE JUST AT THE FRAME STORAGE AREA.

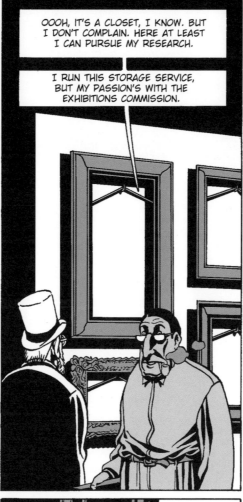

OOOH, IT'S A CLOSET, I KNOW. BUT I DON'T COMPLAIN. HERE AT LEAST I CAN PURSUE MY RESEARCH.

I RUN THIS STORAGE SERVICE, BUT MY PASSION'S WITH THE EXHIBITIONS COMMISSION.

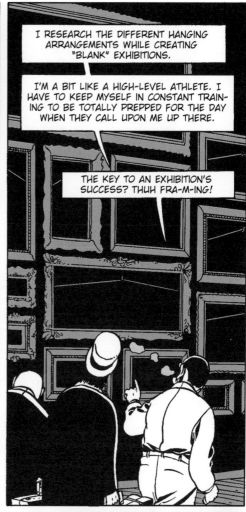

I RESEARCH THE DIFFERENT HANGING ARRANGEMENTS WHILE CREATING "BLANK" EXHIBITIONS.

I'M A BIT LIKE A HIGH-LEVEL ATHLETE. I HAVE TO KEEP MYSELF IN CONSTANT TRAINING TO BE TOTALLY PREPPED FOR THE DAY WHEN THEY CALL UPON ME UP THERE.

THE KEY TO AN EXHIBITION'S SUCCESS? THUH FRA-M-ING!

WITHOUT A FRAME, A PAINTING REMAINS JUST A PAINTING. THIS STATEMENT MAY SEEM ARBITRARY, BUT IT'S AN ESTABLISHED FACT.

IMAGINE, JUST FOR A MOMENT, THE MOST BEAUTIFUL OF PAINTINGS.

NOW IMAGINE IT WITHOUT A FRAME... WITH THE CANVAS NAILED ONTO CRUDE STRETCHER BARS... THE TRACES OF PAINT SPILLING OVER THE EDGES...

HOW SAD!!

NO, EVEN A MASTERPIECE, IF FRAMELESS, IS REDUCED TO THE LEVEL OF A RUN-OF-THE-MILL ARTWORK.

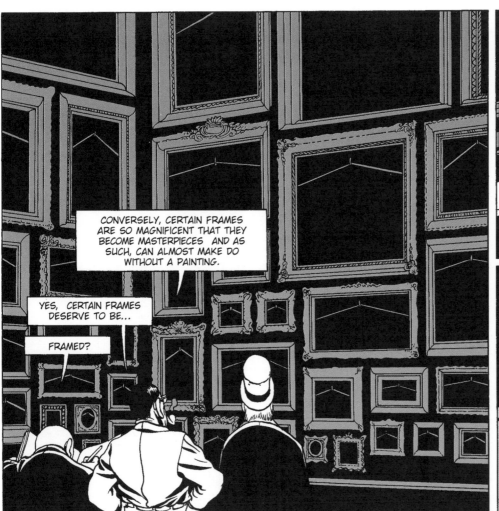

CONVERSELY, CERTAIN FRAMES ARE SO MAGNIFICENT THAT THEY BECOME MASTERPIECES AND AS SUCH, CAN ALMOST MAKE DO WITHOUT A PAINTING.

YES, CERTAIN FRAMES DESERVE TO BE...

FRAMED?

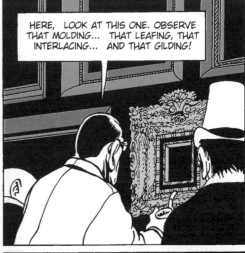

HERE, LOOK AT THIS ONE. OBSERVE THAT MOLDING... THAT LEAFING, THAT INTERLACING... AND THAT GILDING!

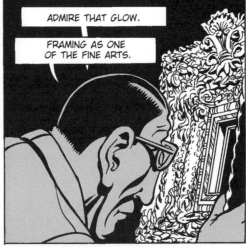

ADMIRE THAT GLOW.

FRAMING AS ONE OF THE FINE ARTS.

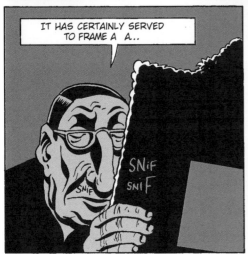

IT HAS CERTAINLY SERVED TO FRAME A A...

SNiF
SNiF
SNiF

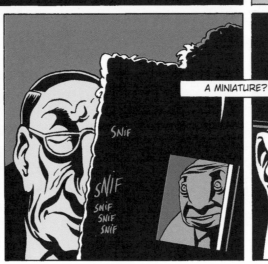

A MINIATURE?

SNiF
SNiF
SNiF
SNiF

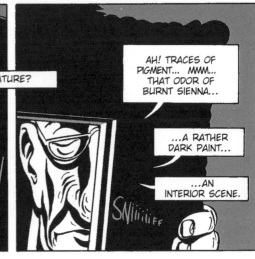

AH! TRACES OF PIGMENT... MMM... THAT ODOR OF BURNT SIENNA...

...A RATHER DARK PAINT...

...AN INTERIOR SCENE.

SNiiiiiFF

LOTS OF DARK SIENNA... A RATHER SOMBER INTERIOR.

SSSSNIF

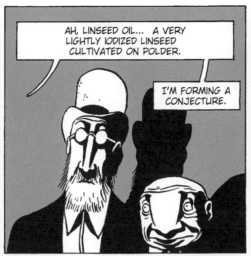

AH, LINSEED OIL... A VERY LIGHTLY IODIZED LINSEED CULTIVATED ON POLDER.

I'M FORMING A CONJECTURE.

A PAINTING OF 11CM X 12CM...

11 X 12... 11 X 12... AH! I KNEW IT.

YES! I GOT IT! IT'S THE PAINTING "U RED LOVE MUSE, U."

...A MINIATURE FROM THE GOLDEN ERA. I MEAN: FROM THE GOLDEN ERA OF GILDING!

THAT'S ALL GONE NOW.

"U RED LOVE MUSE, U"

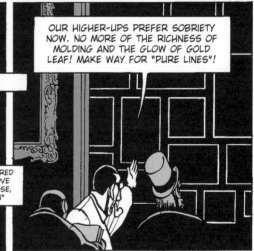

OUR HIGHER-UPS PREFER SOBRIETY NOW. NO MORE OF THE RICHNESS OF MOLDING AND THE GLOW OF GOLD LEAF! MAKE WAY FOR "PURE LINES"!

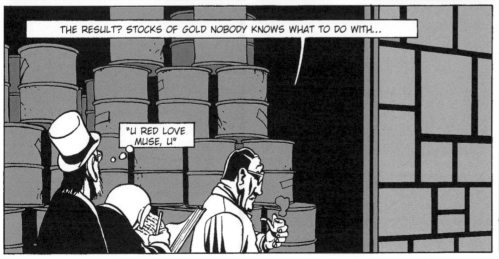

THE RESULT? STOCKS OF GOLD NOBODY KNOWS WHAT TO DO WITH...

"U RED LOVE MUSE, U"

...AND FRAMES REDUCED TO THEIR SIMPLEST EXPRESSION.

47

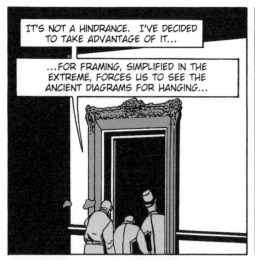

IT'S NOT A HINDRANCE. I'VE DECIDED TO TAKE ADVANTAGE OF IT...

...FOR FRAMING, SIMPLIFIED IN THE EXTREME, FORCES US TO SEE THE ANCIENT DIAGRAMS FOR HANGING...

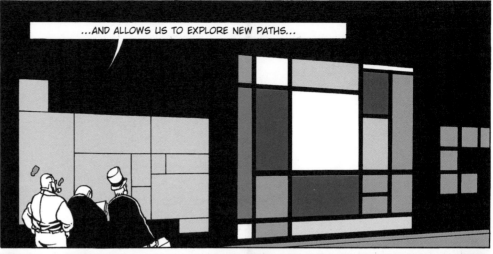

...AND ALLOWS US TO EXPLORE NEW PATHS...

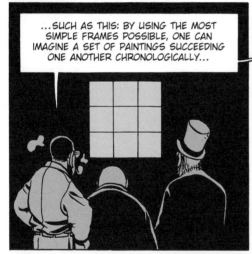

...SUCH AS THIS: BY USING THE MOST SIMPLE FRAMES POSSIBLE, ONE CAN IMAGINE A SET OF PAINTINGS SUCCEEDING ONE ANOTHER CHRONOLOGICALLY...

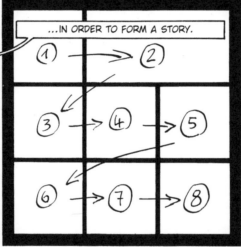

...IN ORDER TO FORM A STORY.

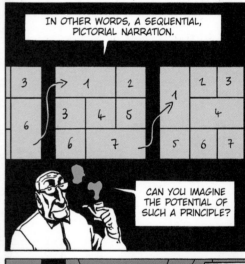

IN OTHER WORDS, A SEQUENTIAL, PICTORIAL NARRATION.

CAN YOU IMAGINE THE POTENTIAL OF SUCH A PRINCIPLE?

YOU MUST UNDERSTAND THAT, UP THERE, THIS KIND OF RESEARCH IS COMPLETELY DISREPUTABLE.

ALTHOUGH I'VE RECENTLY HEARD THAT SOME PEOPLE HAD GOTTEN INTERESTED IN IT.

MAYBE ONE DAY THESE EXPERIMENTS WILL HAVE THE RENOWN THEY DESERVE.

CARDB

MOUNTING

MATTING

GLASS

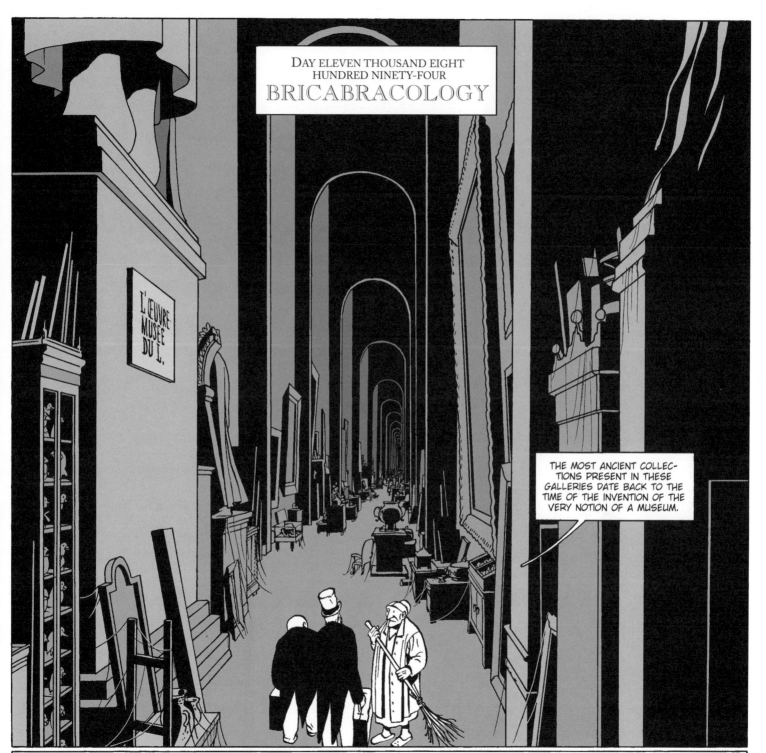

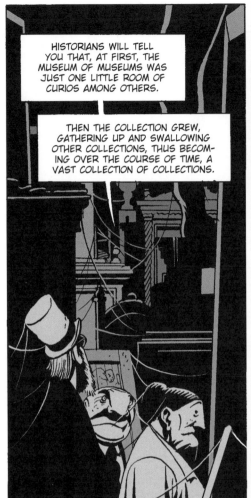

HISTORIANS WILL TELL YOU THAT, AT FIRST, THE MUSEUM OF MUSEUMS WAS JUST ONE LITTLE ROOM OF CURIOS AMONG OTHERS.

THEN THE COLLECTION GREW, GATHERING UP AND SWALLOWING OTHER COLLECTIONS, THUS BECOMING OVER THE COURSE OF TIME, A VAST COLLECTION OF COLLECTIONS.

THAT COLLECTION OF COLLECTIONS CONTINUED TO DEVELOP EVEN MORE! NOWADAYS, IT'S A COLLECTION OF MUSEUMS, WHOSE BRICABRACOLOGICAL STRATA ARE COMPLETELY UNMANAGEABLE.

OH?

IT'S TOO IMMENSE! THE OPERATING BUDGET CAN'T KEEP UP! WE'RE OBLIGED TO RENT OUT SOME SUB-GALLERIES.

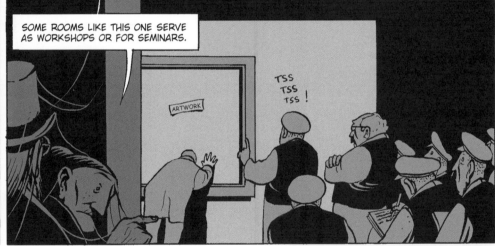

SOME ROOMS LIKE THIS ONE SERVE AS WORKSHOPS OR FOR SEMINARS.

ARTWORK

TSS TSS TSS !

CAN YOU DO THAT FOR ME AGAIN?

ARTWORK

ARTWORK

TSSS TSS TSS !

DON'T TOUCH THE ART.

STOP!

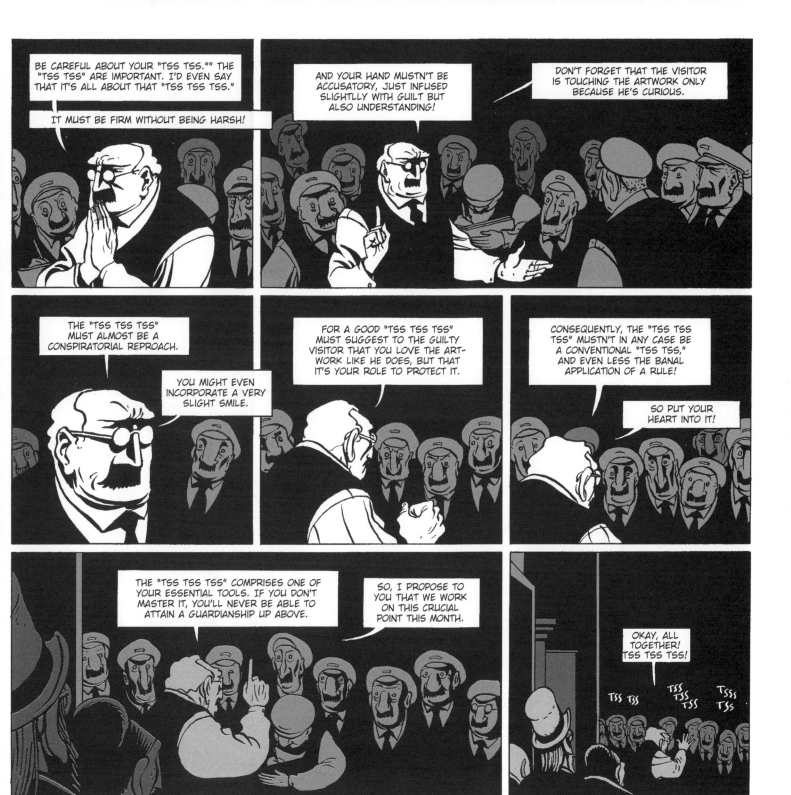

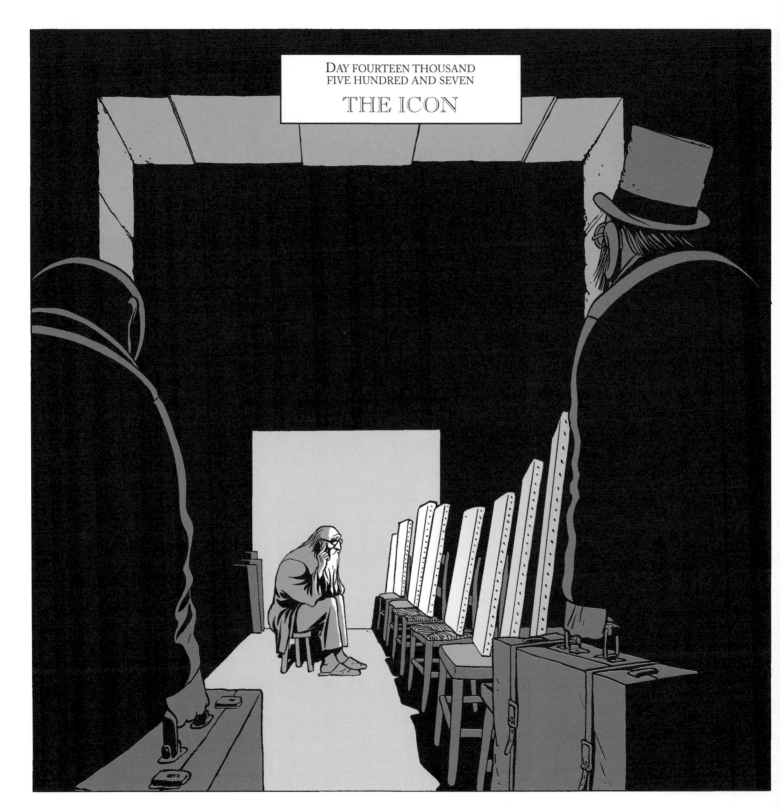

DAY FOURTEEN THOUSAND
FIVE HUNDRED AND SEVEN

THE ICON

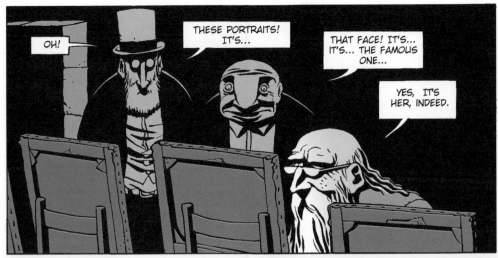

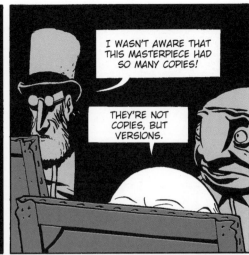

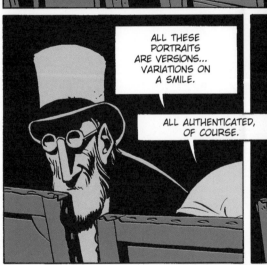

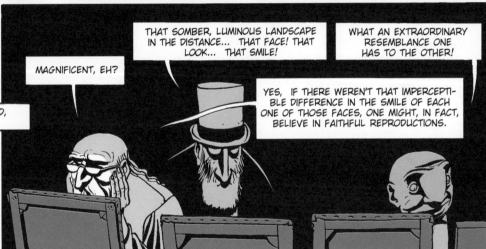

AND OBSERVE THIS PORTRAIT HERE. HERE, THE SMILE'S AMUSEMENT IS SHADED WITH NOSTALGIA WHICH MUST COME FORTH FROM YOU.

THERE, IT'S A SMILE OF GENTLE INDULGENCE. IT MIGHT INDICATE TO YOU THAT YOU'RE DOUBTFUL.

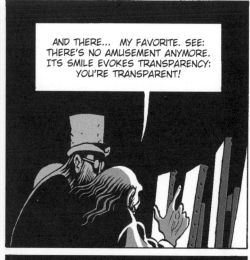

AND THERE... MY FAVORITE. SEE: THERE'S NO AMUSEMENT ANYMORE. ITS SMILE EVOKES TRANSPARENCY: YOU'RE TRANSPARENT!

HERE, THE ARTIST IS MAKING SUCH PROFOUND THINGS EXIST IN US... UNIQUELY BY THE SUBTLE VARIATIONS OF A SMILE!

TO ME, ALL THESE SMILES HAVE REVEALED SO MANY THINGS ABOUT WHO I AM!

AFTER ALL THIS TIME, I KNOW EXACTLY WHAT EACH SMILE SEES IN ME.

WHO SEES WHOM? THAT'S THE WHOLE MYSTERY BETWEEN ARTWORK AND EYE.

WHY ARE THESE MASTERPIECES BEING STORED HERE? WHY AREN'T THEY ON DISPLAY?

THEY'RE EXHIBITED.

THEY'RE ALL EXHIBITED UP THERE, IN THE GRAND GALLERY.

BUT ONE AFTER THE OTHER! AND NOBODY KNOWS ABOUT IT!

THE VARIATIONS IN THE SMILE ARE SUBTLE, AND NOBODY'S EVER NOTICED A THING: THE PUBLIC THINKS THERE'S BUT A SINGLE MASTERPIECE! HEE HEE HEE...

?

YOU'RE GOING TO ASK ME: WHY NOT EXHIBIT THEM ALL AT THE SAME TIME?

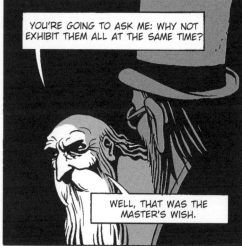

WELL, THAT WAS THE MASTER'S WISH.

SEEN AT DIFFERENT MOMENTS, ALL THESE DIFFERENT VERSIONS FEED INTO THE PERPLEXITY SURROUNDING THE SMILE. AS EVERYBODY DOESN'T SEE THE SAME SMILE, THE INTERPRETATIONS ARE ACCORDINGLY DIVERGENT AND GIVE RISE TO OPINIONS, DEBATES, INTERPRETATIONS, AND EXEGESIS THAT, EACH TIME, ONLY THICKEN THE MYSTERY A LITTLE BIT MORE.

THROUGH THIS PLOY, THE MASTER WANTED TO REPRESENT THE VERY MYSTERY OF REPRESENTATION.

HIS MYSTERY AND HIS SECRET WILL ENDURE AS LONG AS... EXCEPT IF... I RECENTLY HEARD A RUMOR...

SOMEONE HAS INVENTED A MAGIC BOX, A SORT OF CAMERA OBSCURA THAT CAN FREEZE THE REAL AND CAN REPRODUCE IT.

THE DAGUERREOTYPE.

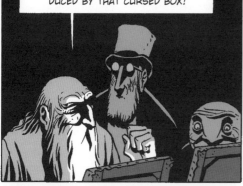

SO IT'S TRUE THEN! AH, HOW SAD... THE DAY WILL COME, THEN, WHEN ONE OF THESE PORTRAITS WILL BE ENSNARED AND REPRODUCED BY THAT CURSED BOX!

THE COLD EYE OF EXACTITUDE WILL IMPRISON THE SMILE ON EXHIBITION THAT DAY! THAT SMILE WILL BECOME THE OBJECTIVE REFERENCE, AND WE'LL NO LONGER BE ABLE TO REPLACE IT WITH THE OTHER SMILES.

ALL THESE WILL THEN BE CONDEMNED TO THE DARKNESS OF THIS STORAGE AREA.

THE CAMERA OBSCURA WILL VERY MUCH DESERVE ITS MONIKER.

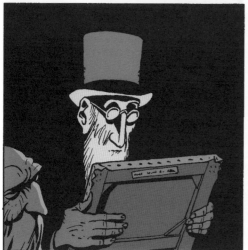

A BEAUTIFUL TITLE, ISN'T IT?

Muse, Lure, Loud Eve

"MUSE, LURE, LOUD EVE ..."

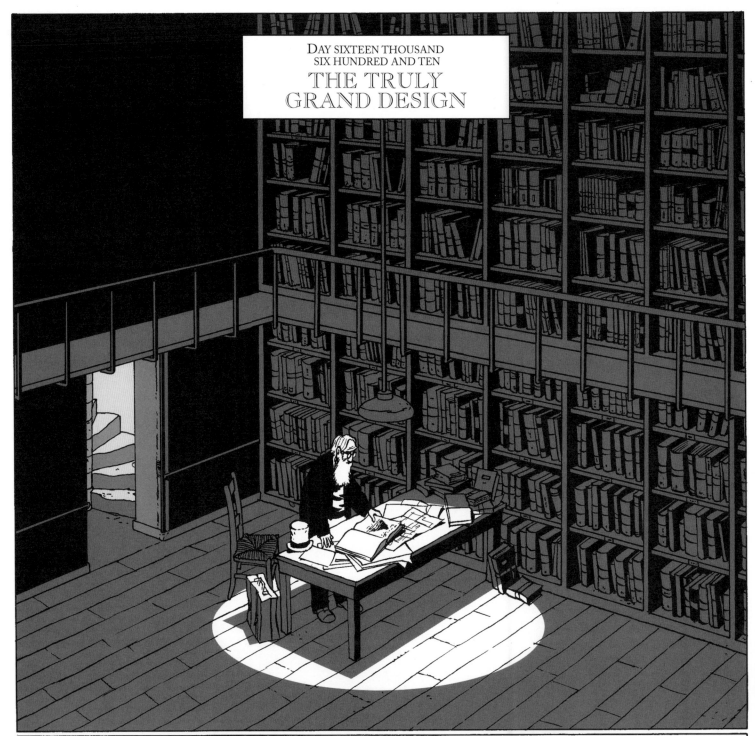

DAY SIXTEEN THOUSAND
SIX HUNDRED AND TEN
THE TRULY
GRAND DESIGN

"LAST MONTH, LEONARD LEFT ME. HE STOPPED IN THE QUARTER OF THE HISTORIANS. HE SAID HE'D FOUND HIS PLACE THERE. SO, ALL ALONE, I'M EXPLORING AN ANCIENT LIBRARY COMPLETELY DEVOTED TO PLANS OF THE SUBBASEMENTS. FOR A WEEK NOW, I'VE BEEN GATHERING RARE INFORMATION ON THE BOUNDARIES OF THE UNDERGROUND AREAS.

I ONLY TOOK INTO CONSIDERATION JUST THE PLACES WHERE THE GALLERIES COME TO AN END, AND I MATCHED UP THEIR POSITIONS IN SPACE. THE RESULT IS ASTONISHING.

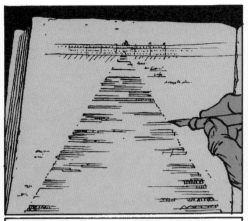

THE ASSORTMENT OF SUBBASEMENTS FORMS A PYRAMID WHOSE PEAK COULD BE SITUATED ON THE SURFACE, ON THE ESPLANADE.

AS FOR THE PILINGS, THERE'S NO TRACE OF THEM ON ANY DIAGRAM. DO THEY EVEN EXIST?

YET IT SEEMS TO ME THAT I'VE VISITED EVERYTHING. FROM THE DEPARTMENT OF ENGRAVINGS TO THE GREAT STORAGE AREA OF MINIATURES, WHILE PASSING THROUGH...

...THE DEPOSITORIES OF MODELS. HAVEN'T I BEEN TO THE VERY LIMITS? WHAT HAVEN'T I EVALUATED, TALLIED, AND INVENTORIED?

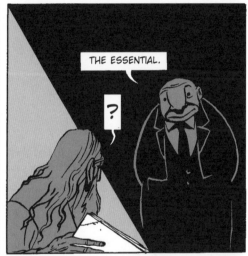

THE ESSENTIAL.

?

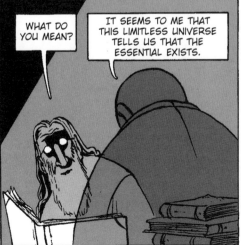

WHAT DO YOU MEAN?

IT SEEMS TO ME THAT THIS LIMITLESS UNIVERSE TELLS US THAT THE ESSENTIAL EXISTS.

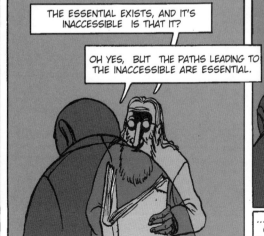

THE ESSENTIAL EXISTS, AND IT'S INACCESSIBLE IS THAT IT?

OH YES, BUT THE PATHS LEADING TO THE INACCESSIBLE ARE ESSENTIAL.

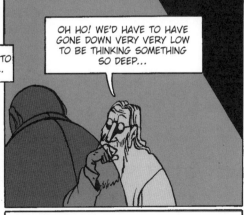

OH HO! WE'D HAVE TO HAVE GONE DOWN VERY VERY LOW TO BE THINKING SOMETHING SO DEEP...

...AND IT'S BEEN QUITE A LONG TIME SINCE I'VE STOPPED COUNTING THE SUBBASEMENTS I'VE GONE DOWN INTO.

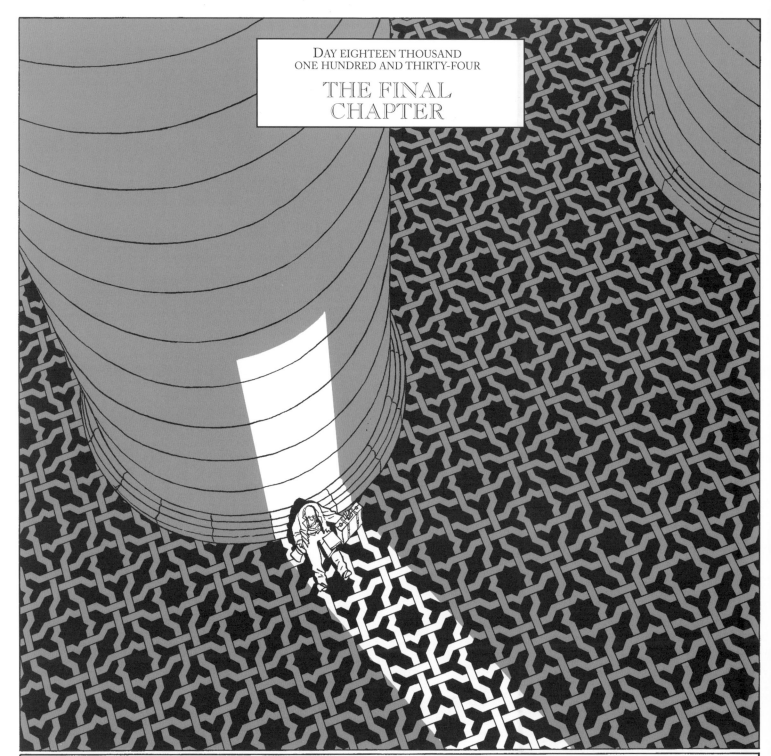

DAY EIGHTEEN THOUSAND
ONE HUNDRED AND THIRTY-FOUR

THE FINAL
CHAPTER

TODAY, I'M ESPECIALLY FATIGUED. I'M RESTING IN ONE OF THE INNUMERABLE INTERMEDIARY SUPPORT
STRUCTURES WITH PILLARS EVER MORE MASSIVE. A VERY LIGHT DRAFT OF FRESH AIR WAFTS THERE.

MY LUNGS ARE WHEEZING LOUDLY...
IT ECHOES AMONGST THE VAULTS.

EUDEUS VOLUMER

I TELL MYSELF: "EUDEUS... EUDEUS VOLUMER,
YOU'VE COME A LONG WAY."

I REALIZE THAT MY NAME IS ITSELF AN
ANAGRAM OF THE NAME OF THE MUSEUM.

HM...WHAT NOW? I SMELL AN
ODOR, OR A SCENT, RATHER.

A SCENT THAT I'D FORGOTTEN... SOMETHING
FRESH... YES... THAT'S IT: IT'S FROM OUTSIDE.

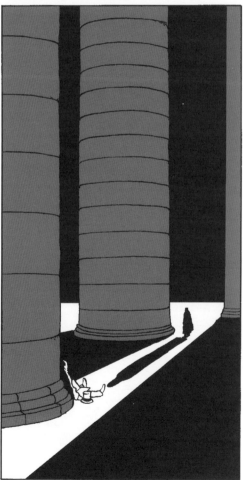

NOW I HEAR SOME STEPS...
THEY'RE COMING CLOSER.

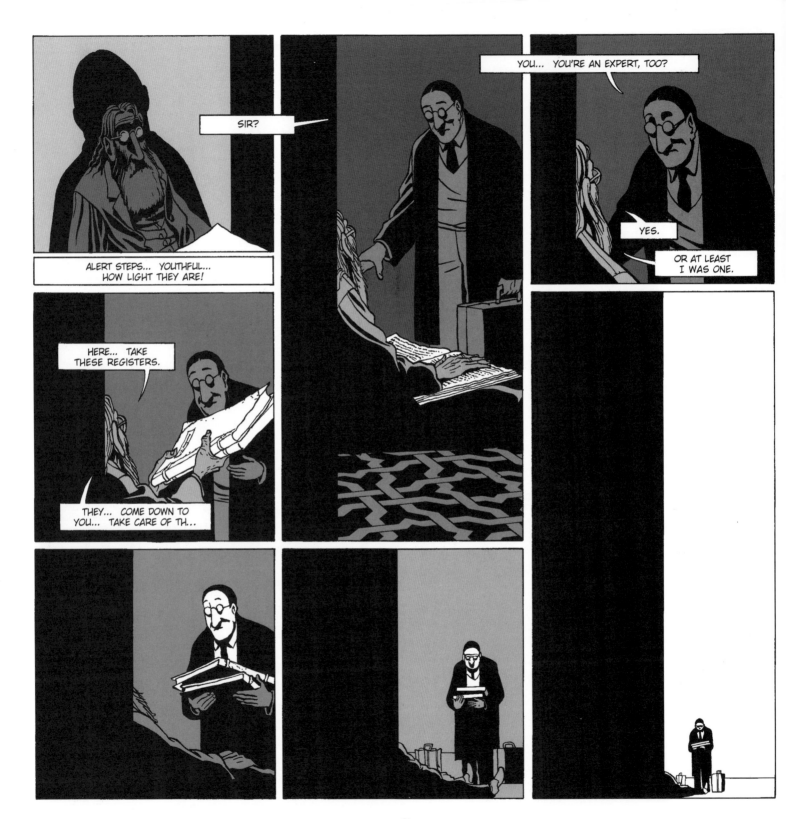

List of works cited

At the Musée du Louvre

p. 27 - Great Sphinx
Dates unknown. Discovered at Tanis.
Granite.
183 cm x 480 cm x 154 cm
Department of Egyptian Antiquities
Inv. A 23

p. 27 - Royal Head, known as "Hammurabi's Head"
From the beginning of the Second Millennium. Susa.
Diorite.
15.2 cm x 9.7 cm x 11 cm
J. de Morgan Excavation
Department of Oriental Antiquities
Inv. Sb 95

p. 28 - Unknown
Copy from the 1st Century B.C.
from an original dating around 110 B.C.
Rome.
Marble. 36 cm
Hoffman Sale, 1888.
Department of Greek, Etruscan, and Roman Antiquities.
Inv. Ma 919

p. 30 - Hubert Robert
(Paris, 1733-Paris, 1808).
Plan for a refitting of the Grand Gallery of the Louvre, 1796.
Oil on canvas. 115 cm x 145 cm
Acquired in 1975.
Department of Paintings.
Inv. RF 1975-10.

p. 30 - Étienne Azambre
(Paris, 1859-Paris, 1933).
At the Louvre, 1894.
Oil on canvas, 61 cm x 41 cm.
Gift from the Society of the Friends of the Louvre, 1978.

Department of Paintings.
Inv. RF 1978-30

p. 32 - Giuseppe Castiglione
(Naples, 1829-Paris, after 1906).
View of the Grand Salon Carré, at the Musée du Louvre.
Salon of 1861.
69 cm x 103 cm.
Department of Paintings.
Inv. RF 3734

p. 33 & 34 - Giovanni Paolo Pannini
(Piacenza, 1691-Rome, 1765).
Gallery of Views of Modern Rome, 1759.
231 cm x 202 cm.
Bequest of Princess Edmond de Polignac,
Born Winnaretta Singer, 1944.
Department of Paintings.
Inv. RF 1944-22

At the Musée du Révolu and elsewhere...

p. 21 - Jasperite pebble,
discovered in 1905 in South Africa,
circa 3,000,000 years B.C.

p. 29 - Nicolas de Crécy.
Glacial Period, 2005 A.D.

p. 35 - 36 - Samuel F. B. Morse
(1791 - 1872).
The Gallery of the Louvre, 1831-1833.
Oil on canvas.
187.3 cm x 274.3 cm.
Chicago, Terra Foundation for American Art,
Daniel J. Terra Collection.

p. 48 - Piet Mondrian.
"Composition in red, black, blue, yellow and gray."

Also available in co-edition with the Louvre:
Glacial Period, $14.95

Add $3 P&H first item $1 each additional.

Write for our complete catalog
of over 200 graphic novels:
NBM
40 Exchange Pl., Suite 1308
New York, NY 10005
www.nbmpublishing.com

Nicolas De Crécy
Glacial Period

A Graphic Novel

THE LOUVRE
From a castle to a museum

From the first walls of Philip Augustus in the 12th Century to the glass and steel structures of I.M. Pei's pyramid at the end of the 20th Century, the transformations of the Louvre have been ceaseless over the course of time.

Kings, emperors, and presidents have almost all set their own mark on this edifice that, from a residence of royalty, became one of the greatest, most prestigious museums in the world.

From Philip Augustus (1180-1223) to Charles V (1364-1380)

Destined to defend Paris against an English invasion, the Louvre was first conceived as a powerful fortification with solid walls. Part of the construction of the walls that ringed the city and thus protected it, this fortress allowed for the direct surveillance of the two main access points coming from Normandy: the river and the great road that led towards the west (the modern-day Rue Saint-Honoré). Moreover, its imposing, 30-meter high central tower symbolized the king's power with respect to his subjects. Charles V, around the middle of the 14th Century, decided to transform the castle in order to make it his principal residence. **1** There are now few visible remnants of that time when the structure, deprived of its military function, was transformed into a sumptuous palace admired by all, for the Hundred Years War proved fatal to it.

From Francis 1st (1515-1547) to Henri II (1547-1559)

After his return from captivity in Italy, Francis 1st decided to refashion the Louvre, the only building in the city capable of housing the king and his court. After some renovations of the old palace, which proved insufficient, the king ordered a more radical transformation of the structure. The modern Louvre was underway. Along with the sculptor **Jean Goujon** at the royal construction site, **Pierre Lescot** was entrusted with the construction of a new wing after a partial demolition of the old castle. **2** Scarcely completed, the new residence was already the source of admiration, marking the apotheosis of

a modern architectural style inspired by Antiquity. A perfect symmetry of ensemble in conjunction with an extremely rich décor demonstrated the most beautiful example of Renaissance décor in Paris. Henri II pursued his father's project while modifying the disposition of the inner parts. He ordered the demolition of the southern wing of the medieval castle, which he had replaced by a modern structure, it too entrusted to Lescot. The king and his family took up residence in the King's Pavilion, a quadrangular tower located at the juncture of the two newer parts of the structure.

From Catherine de Médicis to Louis XIII (1610-1643)

Catherine de Médicis, Henri II's widow, was unwilling to tolerate any further the discomforts of an as yet incommodious palace, and ordered the construction of a new structure located to the west of the Louvre, **the Palais des Tuileries**. **3** In order to connect the two buildings and to thus enlarge considerably the surface area of the palace, construction was ordered by successive sovereigns through Louis XIV. The first stage of this "Grand Design" was the realization of the perpendicular **Petite Galerie** **4** to the south wing of the Louvre. Then, the work on the

"Grand Galerie along the water" 5 (around 450 meters in length), destined to link directly the royal apartments in the Louvre to those in the Tuileries, began under Henri III (1574-1589) and were completed under Henri IV (1589-1610). The only remaining part nowadays is the eastern portion, for it was rebuilt in great part under Napoleon III. Resuming the "Grand Design," Louis XIII had the

western wing of the old Louvre lengthened, enclosing the central courtyard of the palace and, in order to attenuate the monotony of a long, horizontal façade, the architect conceived of a central pavilion in the French style capped with a "French dome" in a square design, framed in monumental chimneys. The proportions thus created were subsequently often imitated.

From Louis XIV (1643-1715) to Napoleon 1st (1804-1815)

At the moment when Louis XIV took over the reins of power, the Parisian castle still presented a very disparate look, with sundry buildings, certain ones of which dated back to the Middle Ages. The Sun King would proceed with the completion of the "Grand Design" by having the northern wings built in their entirety and by doubling the length of the southern wing of the central part of the palace, which then became **the Cour Carrée** (Square Courtyard). These three undertakings illustrate perfectly the different architectural tendencies of the reign of the Sun King. The eastern wing, or the wing of the Colonnade, served as the palace's official façade and the history of its development is long and complex. The architects **Louis Le Vau**, then **Bernini**, who was brought in from Rome, saw the project entrusted to them,

but then withdrawn by Colbert. Finally, the project elaborated by Le Vau and **Claude Perrault**, and no doubt the painter **Charles Le Brun**, carried the day. Sober and monumental, this new wing illustrated how the king and his minister pictured a monument destined to house a sovereign. **6** The colonnade marked the end and also apotheosis of the architectural developments of the *Ancien Régime*, for the

departure of the court for Versailles brought about a royal disinterest in the Louvre. Napoleon 1st, Louis XVIII (1814-1824) and Charles X (1824-1830) transformed the interiors, but did little construction. **The birth of the museum in 1793** signaled the death of the palace of kings and the development of new rooms was carried out to the detriment of the former apartments. **Charles Percier** and **Pierre Fontaine** developed the vestibule and the monumental staircase marking access to the museum.

From the Second Empire through the Grand Louvre

It was only in the 19th Century that the Louvre experienced the most important and most rapid phase of extension in its long history. After his ascendance to the throne, **Napoleon III** (1852-1870) bestowed to **Louis Visconti** the task of executing the project for completing the totality of the Louvre-Tuileries ensemble, which became, at least by virtue of the surface area that it occupied, one of the largest architectural complexes in the world. A new wing located to the north, the length of the future **Rue de Rivoli** whose construction was then still underway, **7** completed the connection between the two palaces. Similarly, the décor of the eastern wing was completed to give to the space a homogenous structure. The completion of the Louvre ended with the almost complete reconstruction of the Palais des Tuileries, but that building was burned during the events of the Commune in 1871, and it was decided ten years later to demolish the ruins. With the disappearance of the Tuileries from the Parisian cityscape, the Louvre began, architecturally speaking, a long sleep lasting more than a hundred years.

It was president François Mitterand who made the decision in **1981** to permit the final transformation of the Louvre. The museum took over the offices of the Finance Ministry, which had been housed for more than a century in the Richelieu Wing. This unprecedented expansion accompanied the reorientation of the collections around the Cour Napoleon where the future entrance to the museum was to be located. The task of drawing up plans for the new construction was entrusted to the architect **Leoh Ming Pei**. **The Pyramid of the Louvre**, **8** despite initial hesitations, was finally chosen to illustrate the museum's passage into modernity.

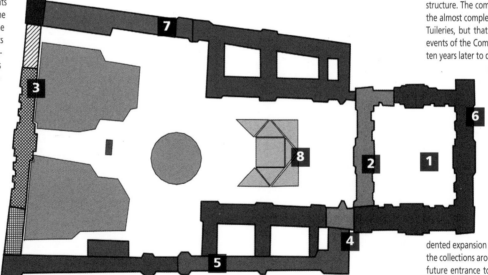